Praise for *Assessment-Powered Teaching*

"The author effectively shows how data-driven decision [...] *ical examples of how this would work in a school. The exam* [...] *provided are easily understandable."*

Stephen Armstrong, Social Studies Department Su[...]**blic Schools, West Hartford, CT**

"We always hear about 'data-driven decisions' but rarely find the information on how to use the data in one place. This book is a one-stop shop for using data to facilitate student learning . . . it provides a practical, hands-on way to handle a task that many teachers find insurmountable."

Nancy Foote, Teacher, Higley Unified School District, Gilbert, AZ

"This book is a must-have for any group of educators that wants to get into the 'nuts and bolts' of what students are learning (or not learning); it sets teachers up for success."

Donna Adkins, First-Grade Teacher, Louisa E. Perritt Primary School, Arkadelphia, AR

"This book offers a step-by-step approach to becoming an assessment-powered teacher."

Diane Callahan, Retired Teacher, West Chester, OH

"Assessment-Powered Teaching provides a wonderful explanation of what to do with all the gems that can be mined from assessment and testing documents."

Roxie R. Ahlbrecht, Second-Grade Classroom Teacher and Math Teacher Leader, Robert Frost Elementary School, Sioux Falls, SD

"The strength of this book is that it has taken all the research and common-sense items about testing and put them into a reader-friendly format."

Shelly Kelly, District Math Instructional Coach, Great Falls Public Schools, Great Falls, MT

"Every teacher wants to know how to effectively and efficiently use assessment results to inform teaching in the classroom, and this book delivers the ways it can be done. It shows teachers how to use formative and summative assessments with a critical eye. Nancy Sindelar is also very supportive of collegial sharing for keeping consistency, aligning standards and making sure all teachers in the same grade or subject are working together successfully."

Maria Mesires, Seventh-Grade Science Teacher, Case Middle School, Watertown, NY

"Assessment-Powered Teaching is straightforward and yet gentle in taking the reader from an understanding of assessment to the pragmatic collection and use of data to the necessary and critical process of professional and collegial dialogue to not only improve student learning, but to improve the craft of teaching as well."

Susan N. Imamura, Retired Elementary School Principal, Honolulu, HI

ASSESSMENT POWERED TEACHING

ASSESSMENT
POWERED
TEACHING

NANCY W. SINDELAR

Skyhorse Publishing

First Published in 2011 by Corwin Press

First Skyhorse Publishing edition 2015

Skyhorse Publishing books may be purchased in bulk at special discounts for sales promotion, corporate gifts, fund-raising, or educational purposes. Special editions can also be created to specifications. For details, contact the Special Sales Department, Skyhorse Publishing, 307 West 36th Street, 11th Floor, New York, NY 10018 or info@ skyhorsepublishing.com.

Skyhorse® and Skyhorse Publishing® are registered trademarks of Skyhorse Publishing, Inc.®, a Delaware corporation.

Visit our website at www.skyhorsepublishing.com.

10 9 8 7 6 5 4 3 2 1

Library of Congress Cataloging-in-Publication Data is available on file.

Cover Designer: Karine Hovsepian

Print ISBN: 978-1-63450-308-2
eBook ISBN: 978-1-5107-0083-3

Printed in China

Contents

Preface

As teachers we are spending more time than ever before testing our students. Though schools have more test data than ever before, many use test results merely to select and sort students and conform to No Child Left Behind (NCLB) requirements. As a result, some of us view testing as a mandate that robs us and our students of valuable instructional time and siphons the creativity from our classrooms. If we make the decision, however, to *use* the results of our tests, we can harness the power of testing as an effective classroom resource to inform our teaching, monitor our students' progress, and get our students energized about their learning.

The purpose of *Assessment-Powered Teaching* is to illustrate the power meaningful assessment brings to the art and science of teaching and to share efficient and practical tools and strategies for using formative and summative assessment results to actually enhance our teaching effectiveness and our students' learning. Using testimonials from assessment-powered teachers, the book explains how teachers at any grade level and in any size school can use analyzed test results to inform teaching, monitor students' progress toward learning targets and standards, and provide motivational feedback to students. The book argues that testing is a power tool for helping teachers rather than an intrusion on our academic freedom and our valuable instructional time.

Assessment-Powered Teaching is based on my own experience as a teacher, department chair, assistant principal, and assistant superintendent for curriculum, instruction, and assessment, as well as my work as a university professor and with schools around the country on curriculum and assessment issues. Though my ideas are supported by current research on assessment, the suggestions in the book are practical and are currently being implemented in high-achieving classrooms across the country. Examples come from small schools and large schools, and practitioners at various grade levels and subject areas provide supporting quotations and vignettes. The examples are

stories from teachers who have transformed their teaching and their students' learning by using test results efficiently and effectively and from my own work, which has moved economically and culturally diverse schools from being on academic watch lists to receiving state-level "most improved" recognition status.

Because the book is meant to be a practical and motivational guide to teachers at all levels, the content is focused on what I believe are key areas of interest to practitioners.

- Chapter 1 engages the reader in the topic of assessment and its value to a teacher.
- Chapter 2 details how a school, a teacher team, or an individual teacher can set up an efficient and effective system for student test data collection and analysis.
- Chapter 3 shows how teachers can use formative assessments to immediately inform teaching, inform teaching over time, and how benchmark and summative assessments can be used to predict scores on high-stakes tests. Because it is not practical for teachers to do test analysis by hand, discussion of practical and easy-to-use methods of computerized test analyses is included. This discussion focuses on how we can make test data useful at the classroom level without dying under the weight of analyzing test data by hand.
- Chapter 4 focuses on ways teachers can help students use their assessment results to define next steps in learning and become more motivated and self-directed in their learning.
- Chapter 5 is devoted to the importance of disaggregating test data to close the achievement gap and increase the achievement of diverse learners.
- Chapter 6 highlights the benefits of team membership and walks readers through the process of successful team meetings.

These chapters outline methods and resources teachers are currently using to empower their teaching and their students' learning. You probably are using some of these methods already, but hopefully you'll learn about some new strategies and resources to reenergize your teaching. Each chapter ends with a rubric enabling you to self-assess your own status as an assessment-powered teacher as well as "Reflections," which provide an opportunity to reflect upon the next steps you'll take to further empower your teaching. Though you'll still be asked to test, test, test, using test results will put you in the position of gaining power and success rather than in the position of feeling like a victim of too much testing.

Acknowledgments

I wish to acknowledge and thank the assessment-powered teachers of our profession who have dedicated so much of their thought and energy to improving the art and science of teaching and accelerating the learning of their students. Some of the teachers mentioned in this book are colleagues with whom I've worked; others are former students. All are respected friends, who have given their much-appreciated support to this endeavor and from whom I've learned so much. I also appreciate the thoughtful efforts of the educators who reviewed the manuscript. Their encouraging, helpful, and provocative comments helped make the book clearer and more user friendly.

Rick DuFour is a colleague whose work and career have been both inspirational and informative. We first met in the summer of 1984 and even then shared mutual interests in common curriculum and assessments. Rick's success is so well deserved, and I truly appreciate his thoughtful endorsement.

Finally, I wish to thank my family and friends for their patience, understanding, and support of my efforts to define and encourage the act of assessment-powered teaching. They are, and always have been, my personal power source.

Publisher's Acknowledgments

Skyhorse Publishing gratefully ackowledges the contributions of the following reviewers:

Donna Adkins, First-Grade Teacher
Louisa E. Perritt Primary School
Arkadelphia, AR

Rachel Aherns, Instructional Strategest I
West Des Moines Community Schools
West Des Moines, IA

Roxie R. Ahlbrecht, Second-Grade Instructor
Robert Frost Elementary School
Sioux Falls, SD

Steve Armstrong, Social Studies Department Supervisor
Connecticut Public Schools
South Windsor, CT

Diane Callahan, Retired Teacher
Fairfield Middle School
West Chester, OH

Gail Corry, Principal
Frontier Elementary School
Payson, AZ

Tammy Daugherty, Third-Grade Teacher
Lakeville Elementary School
Orlando, FL

Nancy Foote, Teacher
Higley Unified School District
Gilbert, AZ

Susan Imamura, Retired Principal
Manoa Elementary School
Honolulu, HI

About the Author

Nancy W. Sindelar, Ph.D., is a consultant to schools across the country in the areas of standards-based curriculum and assessment alignment, collection, use, and interpretation of student test data, teacher mentorship, and the development of high-performing teacher teams. By focusing on data-driven instruction, Nancy has helped schools move from state academic "watch lists' to "most improved" status, based on state test scores.

Nancy writes on educational topics and is the author of *Using Test Data for Student Achievement: Answers to No Child Left Behind.* She also teaches graduate courses at California State University and Roosevelt University, specializing in Leadership of Effective Organizations, School Supervision, School Law, School Curriculum, and Educational Assessment.

Nancy is an executive consultant on assessment for the American Association of School Administrators (AASA) and has spoken at numerous national conferences, including meetings of the Association for Supervision and Curriculum Development (ASCD), American Association of School Administrators (AASA), and the National Association of School Boards (NASB).

Nancy brings to these endeavors over thirty years' experience in public education, as a teacher, department chair, assistant principal, and assistant superintendent for curriculum, instruction, and assessment as well as experience as a university professor. She received her bachelor's degree from Northwestern University, a master's degree from DePaul University, a certificate of advanced studies from Concordia University, and a doctor of philosophy degree from Loyola University of Chicago. She was a visiting scholar with the English faculty at Cambridge University, England, served a four-year term as president of Northwestern University's School of Education and Social Policy Alumni Board, and currently is a board member of the Ernest Hemingway Foundation of Oak Park.

Introduction

Teachers are being asked to test, test, test, but many schools do little with the test results other than sort students into various categories of proficiency or lack thereof. Some teachers feel testing has taken the joy out of teaching. Others believe valuable instructional time has been lost as a result of testing.

Yet as 2014 approaches, the deadline according to NCLB for when all students must meet or exceed standards, we, as teachers, are under increasing pressure to make certain our students meet standards and our schools meet adequate yearly progress. Now, more than ever, we need to embrace testing as a valuable classroom tool to guide instruction, use the efficient technological resources that are available for test scoring and analysis, and profit from the benefits that come from analysis of test results to increase learning, motivate students, and even raise test scores.

As teachers, most of us received little formal training in how to assess students or make use of assessment data. Though tools for scoring and assessment analysis are available and currently exist in many schools, many teachers still engage in the time-consuming task of hand-scoring tests and are unwilling or unable to use the data analysis tools that are available to dramatically increase their capacity to monitor learning and increase students' learning trajectories.

Assessment-Powered Teaching illustrates, step by step, the power teachers can gain from *using* test results from both state and local classroom tests in their classrooms on a daily basis to inform teaching, monitor the progress of all students, and motivate and energize students with the results of their learning. By using test results as an integral part of the planning and teaching process, our teaching improves because we take into account what our students know, believe, and bring to our classrooms, as well as what our students still need to learn. Understanding the needs of our students also guides our broader decisions about curriculum and program design and systemic changes needed for meaningful intervention.

Though tests often are used to separate students and exclude them from programs and opportunities, testing also can be a lever for greater equity in learning and a means for closing the achievement gap. The use of standards-based curriculum and assessments increases the likelihood that students will acquire the same knowledge and skills and have their work judged according to the same criteria. Using results from standards-based tests gives us the information needed to guide our reteaching and intervention efforts. When we disaggregate data from standards-based assessments, we are able to identify the strengths and weaknesses of specific subgroups and thus provide specific subgroup interventions that will close the achievement gap.

Assessment-Powered Teaching explains how an individual teacher, a teacher team, or an entire school can build a standards-based curriculum and assessment system that will provide reliable test results to guide a data-driven instructional process. Assessment options, scoring options, and details on how to use test data in meaningful ways, individually or in a team setting, are discussed. A glossary of terms associated with testing is provided to enhance clarity and understanding of the various resources available to teachers.

Knowing how to use standards to define learning targets, build standards-based curriculum and assessments, gather and use test data in the classroom, and share data-driven teaching strategies with team members gives us, as teachers, power. Knowledge is power, and *Assessment-Powered Teaching* puts it all together in a step-by-step format.

1

Using the Power of Assessment

Assessment of student learning is nothing new. The word *assess* dates back to the Medieval Latin word *assidere,* which means to sit by or attend (Scott Foresman, 1988), and attending to students' learning by using a variety of assessment strategies always has been a trademark of good teaching. Assessments show us what our students know before instruction begins, whether or not our students are understanding the lesson while it is being delivered, as well as what, if anything, our students have learned from the lesson.

Effective teachers use multiple forms of assessment. In addition to tests and quizzes, we position ourselves in classrooms and labs to visually attend to all students' learning and behavior while delivering instruction. Often we can tell whether or not students are "getting it" just by the expressions on their faces. The information we gain from the various kinds of assessments we use, be it formal tests, student discussion, or student body language, has long been the power that drives the numerous adjustments we make to the teaching and learning activities that are taking place in our classrooms.

What is new is that assessments are now being used to hold teachers and schools accountable more than ever before. What students have or have not learned is published in local newspapers, school report cards are sent home to parents on a regular basis, and schools that fail to make adequate yearly progress face serious consequences. To some extent, "testing" has become the dirty word of the education profession. Many

teachers feel they are spending their days teaching to tests they didn't author and that creativity and content are being stripped from their classrooms due to state and federally mandated tests. Clearly, under No Child Left Behind we are being asked to teach differently than we were taught and are also being held accountable for student learning.

The purpose of this book is to rekindle in teachers the power that meaningful assessment brings to the art and science of teaching and to share some tools and strategies that will afford teachers the opportunity to use assessment to enhance teaching effectiveness in an efficient and practical manner. Teachers who have embraced twenty-first century, state-of-the-art assessment practices have been recharged as teachers and have seen student learning accelerate and test scores rise. They are the assessment-powered teachers of the twenty-first century who have embraced change to become more effective and strategic in their teaching and assessment methods. Here their stories will be shared, celebrated, and hopefully replicated by the reader.

These are the steps you can take to become an assessment-powered teacher.

Step One: Become Familiar With Student Assessment Data and Learn to Use It to Enhance Your Teaching

As teachers, we are in the business of constantly assessing our students. We test, test, test! But many of us don't take the time to actually analyze test data to understand the results of our teaching and what our students have or have not learned. Some of us don't know how to analyze test data; others of us don't know what to do with analyses that have been prepared for us. Too often we use test results to assign a grade and don't go any farther. Too often unit and chapter tests signal to us as teachers and to our students that the unit is over, and it's time to move on to new material.

Unfortunately, taking the time to look at assessment results to understand what our students have or have not learned often is forsaken due to the pressure to move on to the next chapter and keep up with the relentless pace of a packed curriculum. As a result, some students are forced to learn new material without the prerequisite skills needed for the new learning that is to take place. Other students have missed the knowledge they will be expected to have mastered later in their educational careers.

The rush to move through the curriculum is a false economy that has a negative impact on learning that multiplies over time as students who miss learning basic information fall further and further behind. As teachers, we all have been guilty of moving on when our students really weren't ready to move on. In doing so, we placed our students in a losing situation, because they weren't prepared for the new material that was going to be presented to them, and simultaneously we created a situation whereby our teaching became less effective. We can, however, remedy this lose-lose situation by taking action and seizing the power that comes from test analysis and using the results of test analysis to reteach when and where necessary.

The data from both classroom tests and state mandated tests can provide us with valuable information to inform our teaching and improve our students' learning. The existence of new assessment software enables us to see the results of our teaching and the progress of our students' learning quickly and efficiently. A variety of easy-to-use software programs are available to schools, and some are even free. These software programs score both forced-choice and rubric-graded tests, summarize data indicating which questions our students know and which they don't know, and show us which standards and learning targets our students know and which they do not know.

Figure 1.1 shows the analyses for a portion of a classroom math test. One of the learning targets was for students to know how to solve problems involving percents and proportions. Questions 52 to 71 tested that learning target. After students completed the test, it was scanned, and a report by learning target was printed. The teacher could quickly see how the twenty-three students performed on each of the questions that measured students' ability to solve problems involving percents and proportions. The asterisk indicates the correct answer, and it's easy to see how students performed on each question as the percentage of students answering each choice is indicated in parentheses.

The report shows that students really didn't have a clear understanding of the learning target. Items 61 and 64 were particularly difficult for this group of students. Only 39% of the class (nine students) selected the correct answer, B, for item 61, and only 43% of the class (ten students) selected the correct answer, D, for item 64. Perhaps items 61 and 64 are poorly worded questions, or there's conflicting information in the text that caused almost half the class to select the same wrong answers, all possibilities for the teacher to explore and clarify with students.

| Figure 1.1 | Sample Item Analysis |

Standard Item Analysis for 23 Students	Course Objective for* Jun 00 M11/1272 ESS of Algebra
08/07/2000 1999–2000 School Year	Course Objectives for ESS Algebra 1

M1173-06 Solve problems using percents and proportions.

(S6D4, S7C4b, S9A 4a, S10A 4a)

Item	A	B	C	D	E	Space
#52	22 (96%)*	1 (4%)	0 (0%)	0 (0%)	0 (0%)	0 (0%)
#53	2 (9%)	3 (13%)	7 (30%)	11 (48%)*	0 (0%)	0 (0%)
#54	0 (0%)	3 (13%)	18 (78%)*	2 (9%)	0 (0%)	0 (0%)
#55	3 (13%)	14 (61%)*	2 (9%)	4 (17%)	0 (0%)	0 (0%)
#56	2 (9%)	2 (9%)	2 (9%)	17 (74%)*	0 (0%)	0 (0%)
#57	0 (0%)	2 (9%)	21 (91%)*	0 (0%)	0 (0%)	0 (0%)
#58	14 (61%)*	1 (4%)	1 (4%)	7 (30%)	0 (0%)	0 (0%)
#59	1 (4%)	21 (91%)*	1 (4%)	0 (0%)	0 (0%)	0 (0%)
#60	15 (65%)*	3 (13%)	3 (13%)	2 (9%)	0 (0%)	0 (0%)
#61	3 (13%)	9 (39%)*	8 (35%)	3 (13%)	0 (0%)	0 (0%)
#62	2 (9%)	4 (17%)	17 (74%)*	0 (0%)	0 (0%)	0 (0%)
#63	13 (57%)*	3 (13%)	5 (22%)	1 (4%)	0 (0%)	1 (4%)
#64	0 (0%)	4 (17%)	9 (39%)	10 (43%)*	0 (0%)	0 (0%)
#65	4 (17%)	2 (9%)	16 (70%)*	1 (4%)	0 (0%)	0 (0%)
#66	6 (26%)	17 (74%)*	0 (0%)	0 (0%)	0 (0%)	0 (0%)
#67	4 (17%)	1 (4%)	18 (78%)*	0 (0%)	0 (0%)	0 (0%)
#68	7 (30%)	1 (4%)	0 (0%)	15 (65%)*	0 (0%)	0 (0%)
#69	12 (52%)*	10 (43%)	1 (4%)	0 (0%)	0 (0%)	0 (0%)
#70	3 (13%)	16 (70%)*	3 (13%)	1 (4%)	0 (0%)	0 (0%)
#71	6 (26%)	6 (26%)	8 (35%)*	3 (13%)	0 (0%)	0 (0%)

SOURCE: Created using the Assessor by Progress Education. From *Using Test Data for Student Achievement: Answers to No Child Left Behind* (p. 69), by N. W. Sindelar, 2006, Lanham, MD: Rowman and Littlefield. Copyright 2006 by Nancy W. Sindelar. Reprinted with permission.

In addition to informing instructional practice, the use of software creates ease and efficiency for teachers because tests are scored and analyzed in minutes, and hand scoring and tallying of test results, which often takes hours of teacher time, are eliminated. Though there are good reasons for hand scoring some tests, use of assessment software affords individual teachers, teacher teams, and professional learning communities (PLCs) immediate access to baseline information about what students know and what they don't know. By getting test results quickly, teachers can begin the important work of changing curriculum and instruction, developing interventions, and providing thoughtful feedback to students.

Though modern assessment software has made it easier to score, analyze, and store student test data, data on student achievement frequently is not used to monitor student performance, even though such data are available (Rosenholtz, 1991, p. 16). Many of us still hand score tests that are written in isolation of state standards, put the grades in a grade book, and move on to the next unit.

We often do not use data from our own classroom tests because we either feel pressured to cover curriculum, don't understand how to actually analyze the results of our tests, or both. Though schools now receive an abundance of data from state mandated tests, it is not unusual for teachers to not "own" the data from state tests because we do not believe the state has tested the true learning that has taken place in our classrooms. In many schools, teachers and administrators do not see much of a relationship between what is being taught and assessed at the local or school level and the state standards, which are assessed by state tests required by NCLB.

Yet for our students to meet or exceed state standards, a relationship between the local curriculum, instructional, and assessment practices and the state standards must be established, and data from both classroom tests and state mandated tests must be used to inform our teaching, change our curriculum, and accelerate the learning of our students. Using assessment software, we can easily use data from our classroom assessments to measure our own students' learning and adjust our daily teaching practices to increase student learning and achievement in our classrooms with the students we know and believe in.

Data from state tests can also be used for more than simply selecting and sorting schools and students *en masse*. As individual teachers, we can use data from state tests to measure the effectiveness of our local curriculum and our classroom assessments to make certain that our local curriculum and assessments are aligned with standards and levels of achievement outside our individual classrooms. This comparison gives us the ability to provide assurances to

parents and community members that the rigor of our local curriculum and assessments will help our students be competitive in national and world markets.

Most of us went into teaching because we loved the energy that comes from being with kids, were passionate about subjects we studied in college, and were energized by the thought that we could make a difference. For many of us NCBL has sapped the enthusiasm from all of the above, and the idea of looking at students' test scores on federally mandated state tests seems overwhelming, irrelevant, or just plain boring.

Yet use of modern assessment software can enhance our effectiveness in all those areas we value as teachers. Use of assessment data can get kids energized about their own learning. It can provide insight into our effectiveness in teaching the subjects we love most. While the use of disaggregated test data truly can help us make a difference in helping *all* kids achieve at higher levels than ever before by diagnosing areas of strength and weakness for individual students as well as student subgroups.

Modern assessment software makes it easier than ever before for teachers to score, grade, and analyze students' work. We no longer have to spend hours hand scoring tests, deciding whether an 89% is a B+ or A−, or wondering if the learning that has taken place is adequate to move on to the next unit. A report based on the data such as those in Figure 1.1 can be generated in minutes to tell us which students mastered the learning target and, if we choose, assign a grade based on our own preset scale.

With a little help from simple technology that is already in place in many schools, we can save hours of grading time and get information that will be invaluable to our teaching. Thus, the first step in becoming an assessment-powered teacher is to become familiar with analyzed student test data and learn to use it to enhance the effectiveness of our teaching.

Joy Joyce, a high school social studies teacher, states,

> I began using the data generated by item analysis when teaching Advanced Placement economics in 1993. Using the data compiled after each chapter or unit test allowed me to effectively target the economic concepts that needed immediate reteaching to the class as a whole and guided the review that would be done immediately prior to the AP test. The combination of reteaching and review resulted in consistently high AP scores in every year's test administration. (personal communication, July 2005)

Joy is just one example of a teacher who learned how technology could simplify data analysis of *her own* tests to enhance her teaching and her students' learning. First, she took control of the curriculum. Then, using data analysis, took the time to understand what her students learned and what they hadn't learned. Using this valuable information, she then retaught where necessary. As a result, her students not only learned the content she deemed important, they were highly successful on the College Board's Advanced Placement tests.

Step Two: Develop an Efficient System for Collecting Meaningful Student Test Data

Key to Joy's success was that her economics curriculum and her local, teacher-made assessments were aligned with the AP economics curriculum and the state standards. Was she "teaching to the test"? Definitely not. She was teaching a standards-based curriculum that was going to be tested, and she used test analysis to identify and reteach what her students didn't know. She was not teaching specific answers to specifically anticipated test questions. Rather, she was reteaching and holding her students accountable for knowledge and analytical techniques that were part of her standards-based curriculum. Assessment analysis revealed to Joy the areas where her students were proficient and those where they were weak. Using test analysis she was able to plan instruction and reteach to promote more areas of proficiency. The alignment of her local curriculum and assessments to standards became the system that allowed her to collect meaningful data about what her students did and did not know.

While more and more schools are aligning their local curricula to state standards, it still is not at all unusual for lessons to be taught in isolation of state standards. There are districts that believe, "We hire the best [teachers] and stay out of their way." As a result, many teachers develop their own curriculum and assessments that are not linked to national or state standards. Also, curriculum for a particular course or grade may only be tied to a textbook that may not address a particular standard.

Because the goal of a standards-based curriculum and assessment system is to improve learning by defining and measuring what students need to know and be able to do, the increase in focus changes what and how we need to teach. When standards, local assessments, and local curriculum are aligned, "teaching to the test" becomes synonymous with teaching what students need to know and

be able to do. When we use a standards-based curriculum and standards-based local assessments, we are not teaching individual test items that we think might be tested, but rather we are teaching the standards, testing to see if our students understand the standards, and reteaching and providing interventions when they don't. When our students take the state mandated tests, they do well because they know the standards we have taught and tested at the local level.

To develop an efficient system for collecting meaningful student data, it is helpful for teachers to work together—-either in grade-level or subject-area teams or with a colleague who also wants their students to achieve similar standards-based learning targets. Planning and teaching in isolation does not enhance the power of the teacher. Teachers, particularly new teachers, need support both from administration and teacher teams to audit their existing curriculum against standards, discuss the instructional activities that will allow students to meet standards, and develop the assessments that will measure their students' progress toward meeting standards and learning targets.

A mature model for teachers to consider is the College Board Advanced Placement Program. In existence for many years, the program has a standardized curriculum and common assessments, which students across the country take. The program holds schools, teachers, and students accountable for a rigorous curriculum and thoughtful, challenging common assessments. Students are rewarded, based on their test scores, with college credit, and teachers meet to review the results of their teaching and improve their curricular and instructional skills in highly regarded summer workshops.

Adjusting one's personal curriculum to state standards can be an awkward change for many of us. We may feel the state is not the best judge of what students should know and simply don't like being told by the state what to teach. Yet once we compare what we are teaching to the state standards, audit our local curriculum in light of state standards, and make the appropriate adjustments to eliminate curricular redundancies and gaps, we find that we have written a local, standards-based curriculum that we can embrace.

Similarly, once our local, teacher-made assessments are written to align with the standards we want our students to know, we own these local assessments and find we have created an efficient system for collecting useful data from our assessments, which can be used to diagnose areas where our students are weak and define areas for curriculum revision and reteaching. Soon we also learn to measure student progress along the way by writing shorter

formative assessments to diagnose our students' learning needs and to help guide our own efforts as we teach.

After we align our local curriculum and assessments to standards, we experience a gradual shift in our understanding and use of assessment. We use our quizzes and unit tests as assessments *for* learning rather than assessments *of* learning. Rather than just putting another grade in the grade book, we analyze test results, diagnose learning difficulties, and identify the next steps we need to take to remediate our students' weaknesses. We ask ourselves, "What worked?" "What should be changed?" and we quickly learn that we have the answers to these questions. When it is time to put the grades in the grade book, we see that our struggling students have made progress, and we are energized by the knowledge that we have made a difference. We come to understand the power that comes from using test data to refocus our instruction and perhaps our curriculum to improve the learning that takes place in our classroom with our own students.

As we progress week to week through the curriculum, we use analyzed test data to understand what our students are learning and what they are not learning. With time, we *and* our students become hungry for data as well as knowledgeable consumers of data. Our students begin to self-assess and understand how to improve their work and actually become motivated to do so. As teachers, we see the power that comes from using data and have new control over the teaching and learning that is taking place in our classrooms. Rather than feeling controlled by "the testing movement," we are using the testing movement to empower our teaching, and we feel a new sense of control as the teacher.

Each lesson, in a sense, becomes a microcosm or piece of the entire standards-based curriculum. At the beginning of each lesson, we ask ourselves: What do I want students to know? How will I know if they know it? What will I do if they don't? We view each lesson as a segment of the standards-based curriculum, and use analyzed formative and summative assessments as a means to guide our instructional strategies and activities and enhance student learning for all of our students.

In this new paradigm, our assessment strategies still include quizzes and unit tests, students' responses to questions, students' body language, students' participation in learning activities, and all the formal and informal actions we have always taken to monitor the learning of our students. But now we also know the power that comes from having concrete information from analyzed test data to really know what our students have and have not learned.

Step Three: Learn How to Use Student Test Data as an Individual Teacher, a Team Member, and as Part of a Schoolwide Initiative

Since the beginning of time, teaching has been a solitary and isolated activity. For years, teachers were trained and then given the freedom to go to their classroom, shut the door, and do what they thought best. Academic freedom is highly regarded by teachers, and state tenure laws were enacted to preserve and protect this freedom. While the ideas set forth in this book have value for the individual teacher, many schools and teachers have come to understand the power that comes from teachers meeting in teams and professional learning communities to develop common curriculum and assessments, review analyzed test results, and share best practices.

Many schools have realized that grade-level and subject teams have the opportunity to be more than just the sum of their parts and that a successful face-to-face group is more than just collectively intelligent. "It makes everyone work harder, think smarter and reach better conclusions than they would have on their own" (Surowiecki, 2004, p. 176). As a result, many teachers now share their ideas and the results of their teaching, rather than working in isolation behind closed doors. With the use of data in team meetings teachers see the strengths and weaknesses in their teaching, their students' learning, their curricula, and their assessments. Rather than simply moving on to the next unit of instruction, they work with their colleagues to build on the strengths and make changes to remediate the weaknesses of their teaching as well as their students' learning.

Laura Swartzbaugh, a high school American studies teacher, states,

> As a teacher and an instructional leader, I have found conversations with fellow teachers both within my department and across departments to be the most enriching "professional development" experience I've had. As opposed to outside experts coming into the school to "tell" us something new about education, we teachers open each other's eyes by stumbling upon shared experiences, challenges, and innovations. Formal and informal conversations amongst teacher and staff almost always result in a new perspective on a student, a teaching method, or an aspect of school culture. Perhaps the most exciting aspect of these conversations is that they echo the classroom so accurately. Teachers and administrators benefit from the reminder that they too are learners in this community. (personal communication, December 2007)

For team meetings to be truly effective, team members need to look at data, data that reflect the results of their teaching and their students' learning. Using team time to merely talk about school is wasteful when compared with using data to evaluate the results of our teaching and our students' learning,

Initially, working in teams may seem like an invasion of privacy. We may not want the results of our teaching or our students' learning shared with colleagues, or we may not want to take the time to meet with our team. It doesn't take long, however, for even the most reluctant team member to discover the power that comes with reviewing test data and sharing ideas and best practices with colleagues.

Though there may be initial reluctance to join a team because we feel there's nothing wrong with our teaching and meetings will just be a waste of time, we begin to feel a compelling reason to practice differently when there is direct evidence that our students are not performing as well as others. We also learn that teams are not inherently inefficient. With time, team protocols are established, teams move though their agendas with purpose, and time taken for deliberation becomes worthwhile because it's centered on data and ultimately improves learning.

While assessment analysis is meaningful to the individual teacher and the teacher team, it benefits from the support of the school system. For data to be used to inform team meetings, technical assistance and organizational capacity is needed. On the technical side, this includes a provision for data analysis in a timely and efficient manner. On the organizational side, this means structures and resources to nurture common curriculum and assessments and time allotted for team meetings.

The ideas in this book can be applied by an individual teacher, a teacher team, or an entire school. While the power of an entire school using data analysis to drive instruction is impressive, so is the power of a small team of teachers agreeing to analyze and share the results of their teaching, and so is the power of an individual teacher who uses data analysis and sees the compelling evidence to practice differently.

Chapter One Rubric: Using the Power of Assessment

	Not Yet	Sometimes	Always
Step One: I am familiar with my students' test data and use it to inform my teaching.			
1. I am familiar with students' test data and review student test data from state mandated tests to measure the impact of my own teaching and the curricular materials I use.			
2. I review the results of my classroom tests to check for student understanding and to know if my students are "getting it."			
Step Two: I have a system in place for gathering and analyzing my students' test data.			
3. Classroom assessments are focused on clear standards-based learning targets.			
4. Curriculum and learning targets are aligned with key standards.			
5. Classroom assessments "match" my standards-based curriculum.			
6. When I look at the results of my classroom tests, I know what my students know and what they don't know.			
Step Three: I use test data to inform my teaching and work with other teachers to develop interventions and share best practices.			
7. Based on the results of my classroom tests, I reteach when necessary.			
8. I am (or would be) willing to share the results of my teaching with my colleagues in a team meeting.			
9. I am (or would be) willing to teach differently to enhance the learning of my students.			
10. My school supports using data to inform teaching by supporting time for teachers to meet and a means for timely access to analyzed test data.			

Reflections

Ways this chapter has changed my thinking:

1.

2.

Next steps:

1.

2.

2

Creating a Data-Driven Instructional System

If the concept of using test analysis to empower teaching and learning in your classroom has caught your interest, this chapter will show you how to get started in the process. Whether an individual teacher, a team of teachers, or an entire school embraces the concept, the steps for setting up a data-driven instructional system are nearly the same.

Identifying standards-based learning targets is key to answering the question, "What should students know?" and the analysis of your students' answers to standards-based formative and summative assessments is how you will answer the question "How will I know if they know it?" This process of assessing learning targets gives us, as teachers, regular and timely feedback regarding our students' attainment of key standards and fosters consistent instruction and assessment across grade levels and courses. More importantly, formative assessment results enable us to diagnose our students' learning needs accurately and in time to make meaningful instructional modifications (Ainsworth, 2007).

In the era of No Child Left Behind and the incentives tied to students doing well on state mandated tests, most schools are aligning their learning targets, assessments, and curricula with state standards. However, there also are national standards, Advanced Placement standards, and others that offer focus for curricular alignment. What is important is that learning targets, assessments, and curriculum be aligned to an agreed-upon set of standards.

Once you have identified the learning targets for your students and have aligned your assessments, curriculum, and instruction to these targets, you will have built the driving force of a data-driven instructional system. Whether you're working as an individual teacher or as part of a grade-level or subject-area team, it is this alignment that will power your ability to gather, analyze, and use meaningful student test data to increase learning and student achievement in your classroom.

Step One: Define Your Learning Targets

To get started, you or you and your team need to decide what it is you want your students to know. For most of us, the answer lies within the state standards, which are in place throughout the country. For the most part, states have helped schools by deconstructing standards into standards-based learning targets. In 2010 the Colorado Department of Education clarified Colorado's standards by defining "expectations" for each grade level. Though the terminology changes from state to state, the point is that in addition to standards, states are making the effort to translate standards into student-friendly, grade-appropriate language that communicates to teachers, students, and parents what students are responsible for learning.

When defining your learning targets, you need to have whatever standards you want your students to learn close at hand. It's also a good idea to review state test data for your school to determine standards that are "key" based on difficulty and number of test items, as well as to identify areas where students' scores are low.

If you are using state standards, you probably won't be able to make each standard a learning target. Rather, you will bundle some of the standards together because they seem similar, while you will unpack others into separate targets because of the complexity of the standard. As you develop your learning targets, keep the following in mind:

1. A standards-based learning target may include more than one standard.

2. A standards-based learning target may include only part of a standard.

3. A standards-based learning target will focus on key skills, concepts, and facts that are critical to student success in future coursework and life.

4. A standards-based target is heavily assessed on a high-stakes summative test.

5. A standards-based learning target is formatively assessed as instruction progresses.

6. If you made all your state standards learning targets, the standard K–12 education would need to become a K–22 experience! (Marzano, Kendall, & Gaddy, 1999)

Step Two: Begin Building Your Standards-Based Assessments

By aligning your local formative and summative assessments to your newly defined learning targets and standards, you will be able to gather test data that will begin to create a comprehensive picture of your students' progress toward learning targets. Your summative assessments will focus on several learning targets, will be used for a grade, and will usually take the form of a unit test, quarterly assessment, or end-of-course exam. These tests are summative in that they record achievement of learning targets and standards at a particular point in time. However, they are formative in the sense that they can predict results on high-stakes state tests.

Your formative assessments will be shorter tests and probably be aligned with only one or two learning targets. You will use these tests to give yourself and your students feedback regarding their progress toward targets and to guide your reteaching efforts.

Don't worry about immediately changing all the tests you use into standards-based assessments. Change is a process, and you might want to begin by first aligning unit tests or other summative assessments to learning targets and gradually add more and more standards-based formative assessments to track your students' progress along the way. As you begin to see the results and benefits gained from standards-based assessments, you will want to align all your assessments to your learning targets. When you have aligned both your formative and summative assessments to standards-based learning targets, you will have created an assessment system that will enable you to collect assessment data to guide and record your students' progress toward standards-based learning targets.

If you're the only teacher for a grade level or subject, you will build your own standards-based assessments, though it's helpful to check your state's department of education website or collaborate

with other teachers in your state via blogs or discussion boards to define key learning targets. If you are working in a school with multiple sections of a subject or grade level, then your efforts will be directed toward working with colleagues in a team setting to build common assessments and common curriculum. Though team meetings take time, team discussions about what students should know and when they should learn it become positively anticipated events that lead to an improved curriculum and to more focused teaching and learning.

Whether you're an individual teacher or part of a teacher team interested in building assessments aligned to standards-based learning targets, consider the following process as you build your standards-based assessments:

1. After the standards-based learning targets are established, you need to identify one or more formats for either the formative or summative criterion-referenced test (CRT) you plan to create to assess student progress toward one or more standards-based targets or standards. Whether you are an individual teacher or a member of a teacher team, you will consider whether the assessment will be formative or summative and whether it will be an essay, a speech, a project, a lab, or a forced-choice test.

If the assessment assesses students' understanding of a number of targets in the form of a forced-choice test, this assessment will look similar to the traditional forced-choice unit test or final exam. However, the assessment could also be a rubric-graded project or a lab exercise. In this case, the rubric will contain the standards or the targets that were taught to the students, and you will grade your students based on their knowledge of each standard or target. Either type of assessment will test students' understanding of the identified learning target(s) and/or state standard(s) and provide you with valuable information—for guiding future instruction if it's a formative assessment and for documenting achievement if it's a summative assessment.

2. When the type of assessment has been determined, you or you and your team need to agree on test items or the criteria for the project and the associated common rubric. It's often helpful for teachers to select test items or ideas from their individual tests and projects for a new common assessment. These assessments will be standardized common criterion-referenced tests to provide data for each student in relation to the learning targets. While certain assessment formats lend themselves to assess some targets better than others, a variety of

assessment techniques is desirable because any one assessment format will favor some students and penalize others (McTighe & O'Conner, 2005).

3. It is helpful to "pilot" a new assessment with a class or group of students to maximize alignment with the standards-based learning targets and check for poorly written items. Once a small group of students has "piloted" the test, the piloted test can be scored and analyzed, and weak items can be eliminated or replaced.

Rubrics used for performance assessments need to be checked for "interrater reliability," which determines that performances are rated consistently by different teachers (raters) over time. Training teachers or raters using models of performance assessments that produce high, medium, and low scores based upon defined criteria strengthens interrater reliability.

4. Modern assessment software allows us to analyze students' answers by learning target or standard, and data analysis reports can be provided to teachers and teacher teams, as well as students, in a timely manner. By reviewing an item analysis by standard or learning target, we can determine how an individual student, a class, or a group of classes performed on a specific learning target. These reports provide teachers, students, and administrators with valuable information regarding what a student knows and what a student doesn't know and serve an important role in determining next steps for instruction, changes in the curriculum, and student self-help activities.

5. Finally, individual teachers or teacher teams need to meet to study assessment results and identify action plans for curricular revision and areas for reteaching and individual student remediation. These meetings are staff development at its best.

Though building standards-based assessments and curriculum involves effort, accountability, equity, and achievement are greatly enhanced by the teams' efforts. Greater demands for accountability in the form of higher test scores have come from many state education reforms, and, most recently and forcefully, from federal government in the No Child Left Behind Act. Though all teachers do not support the NCLB approach, the forces demanding increases in student test scores will have a potent impact on us as teachers for many years to come. As a result, what is taught and tested needs to be aligned with standards, the results of students' tests must be analyzed, and professional development efforts need to be tied to improvements in classroom teaching and learning.

Looking at data from standards-based curriculum and assessments is the most effective means for us to bring about significant changes to address the demands for greater accountability because it is through these means that we can actually account for which standards our students know, which standards they do not know, and then make adjustments in instruction to raise achievement levels of all students.

More importantly, the use of data from standards-based curriculum and assessments promotes equity, is a powerful tool in closing the achievement gap, and helps us to enhance the achievement of *all* students. The use of standards-based curricula and assessments increases the likelihood that students will acquire the same knowledge and skills and have their work judged according to the same criteria. The use of data from standards-based assessments helps us to identify our students' strengths and weaknesses and thus provide specific interventions to remediate their weaknesses.

Because modern assessment software enables us to disaggregate common assessment test data for subgroups, low-achieving subgroups are no longer hidden in high-achieving classrooms and can be offered the interventions and equity they deserve. As far back as 2001 Michael Fullan urged schools to work toward assessment literacy by examining student performance data, disaggregating data to identify subgroups that may be disadvantaged or underperforming, and, based upon data, make changes in teaching and action plans. Unfortunately, the disaggregation of local test data still is not happening in many schools and classrooms

Finally, the most powerful method for increasing learning and raising student achievement is created by the dialogue that occurs when grade-level and subject-area teacher teams review and compare common assessment results, share teaching strategies, and come to agreement regarding action plans and interventions to help individual students, student subgroups, or entire classes. Etheridge and Green's 1998 study, which interviewed individuals from six school districts who used curriculum groups to plan for instructional improvement, found that the review and analysis of assessment reports and data-based suggestions for program changes to increase student acquisition of problematic concepts generated remarkable, if not unprecedented, gains in student achievement.

Though we have never suffered from a lack of data, receiving specific feedback regarding the proficiency of our own students on a learning target our team has agreed is essential, on an assessment our team has agreed is valid and fair, and then comparing the achievement of our students to the achievement of other students attempting

to achieve the same standard transforms simple data into powerful information for us as teachers. When we learn that some of our students are not performing as well as others, we now have compelling reasons to teach differently and work with our team members to create systems of intervention for our students who are struggling.

The options for standards-based assessments are many and will be discussed more fully in Chapter 3. What is important is to begin developing a data-driven instructional system by identifying learning targets, building key common assessments, and deciding when they will be given. Not every assessment needs to be a common assessment. There will always be the need for individual teachers to monitor student learning through the wide variety of strategies and formative assessments that we have always used to check for understanding. It is important, however, for us to stay focused on the standards and be disciplined about having both our curriculum and our assessments reflect the standards.

Step Three: Align Your Curriculum With Learning Targets and Assessments

Once learning targets have been identified and assessments written, the next step is to align the curriculum to the standards-based learning targets. A standards-based common curriculum nurtures equity in that it defines what all students are expected to know and promotes achievement in that it allows us to easily measure what students do and do not know.

As a teacher of a single grade level, you can follow the process outlined. More than likely, however, you are teaching in a school with more than one section or class of your grade level, or more than one section of a particular class, say Algebra I, at the high school level. In the case where there's more than one class or section of a particular subject, then you and the other teachers need to go through the process together to agree on common learning targets, some common assessments, and a common curriculum. While it does take some time to reach agreement, common curriculum creates equity in learning, is key in monitoring student progress, and is necessary for "closing the achievement gap." It's totally worth your time and effort to work with colleagues to develop a standards-based common curriculum.

Grade-level or subject teams work well for developing a common curriculum, and most educators find it enjoyable to get together with colleagues to discuss what they are doing in their classrooms. Generally, when teachers meet in grade-level or subject-area teams and

compare what they are teaching, they find very few differences in the courses of study they individually have designed, are fascinated by the array of methods and materials their colleagues are using to engage students with the subject matter, and soon decide to "share the wealth" within their grade-level or subject-area teams on a regular basis.

Whether you're an individual teacher or part of a teacher team interested in building a curriculum aligned to state or national standards, you should consider the following ideas:

1. Begin by describing your existing curricula by collecting unit plans, syllabi, and major projects. Next, determine and document what is currently being taught at a particular grade level in each subject area. Consider beginning with a grade-level subject such as math and work through the process, or, at the high school level, begin with freshman Algebra or English I. Choose a subject that is important because it is tested by the state or because a lot of students take it or both.

Once each teacher shares what is being taught in his or her individual classroom, common curriculum learning targets for the grade and subject can be identified by the team. This process clarifies the targets of instruction for the teachers and provides teachers, students, and parents with the essential information regarding what students are expected to know.

Also, it is at this point that teacher teams will decide on the curriculum they will *all* follow and the pacing they will *all* use. Common curriculum pacing means that teachers agree to cover the same material at a similar rate: for example, Chapters 1 through 8 will be taught by Thanksgiving. However, pacing and instructional strategies on a daily basis are left to the discretion of the individual teacher. While this is *not* a lock-step approach, developing a common curriculum and agreeing on pacing is key to developing a system for collecting assessment data because it is at this step that we document what students should know, when they should know it, and, at a key juncture, assess students to determine if they know it.

2. Once you outline what currently is being taught at a given grade level and subject area, compare the taught curriculum with the newly defined standards-based learning targets and assessments. It is the state standards that are tested on the state tests. Thus, if students are going to do well on state and national exams, the topics on those exams must be taught and locally assessed at the appropriate grade level. This seems like common sense. Yet, it is not at all unusual to find that key standards tested on state tests are not taught at all or are not taught at the appropriate grade level. A frequent cause for this situation is that a standard is not in the textbook for the course. Thus it

is forgotten. As one Illinois principal recently said, "It's no wonder our students don't do well on this part of the state test. It's not even covered in our textbook!"

3. Next, you will revise the taught curriculum to eliminate redundancies and fill in gaps. When what is currently being taught is compared to your new learning targets, it is easy for individual teachers and/or teacher teams to identify redundancies and gaps. It is not unusual for the same standard to be taught over and over and other standards not even touched. When curricular redundancies are eliminated, the pressure of a packed curriculum is eased and time becomes available for teaching the previously neglected standards.

4. Once the curriculum for a given grade and subject area is complete and the redundancies and gaps have been eliminated, it is helpful to link the curriculum objectives to the alphanumeric system used in the state standards. This step allows for easy reference to the standards that are being taught.

5. The final touch to revising and refining your common standards-based curriculum is to attend to both horizontal and vertical alignment issues. Horizontal alignment means checking to see that *all* teachers at the same grade and subject area are following the new common curriculum and moving through it at about the same pace. When all teachers at a given grade and subject level develop and follow a common curriculum that addresses standards and give at least some key common assessments, it becomes possible to collect uniform data to monitor students' progress in learning the standards-based learning targets.

Vertical alignment deals with sequence, or what students have learned before and after a given grade level. Once a curriculum has been developed for a given subject at a number of grade levels, it is a good idea to have vertical teacher team meetings review curriculum objectives for each grade level. Thus, fifth-, sixth-, seventh-, and eighth-grade teachers would review the math curriculum to make certain that each grade level builds on previous levels and also prepares students for what is to follow.

A Word About Curriculum Mapping

When recorded on a curriculum map, the alignment of the curriculum with state standards and standards-based learning targets clarifies for

teachers the targets of instruction, the materials to be used, and the specific learning activities for students. It also provides teachers, students, and parents with essential information regarding what students are expected to know and be able to do.

Sample formats for curriculum and assessment alignment to learning targets and standards are provided (Figures 2.1 and 2.3). However, you should feel free to modify these formats or modify the formats currently in place in your school to be teacher-friendly, user-friendly documents. The important elements that should exist in a curriculum map for common standards-based curricula are

- clearly stated learning targets/standards,
- an assessment for each of the targets/standards,
- a notation regarding the state standard that the learning target and assessment address, and
- resources and activities used.

Figure 2.1 is a portion of a third-grade curriculum and assessment map outlining the learning targets and assessments for studying citizenship. Courteney Famulare, the third-grade teacher who developed the social studies example, made the following decisions:

1. Her third-grade students would meet the state social studies standard, requiring the study of civics, by completing a unit on citizenship. Through the study of citizenship her third graders would meet the state's third-grade learning expectation (GLE) that "Respecting the views and rights of others is a key component of a democratic society."

2. The learning targets (or skills) her students needed to have in order to meet the standard and grade-level expectation set by the state were to be able to demonstrate citizenship within the community, explain why citizenship is important, explain different ways they could make a difference in their community, understand the purpose of the Bill of Rights and Constitution, and understand their own rights and responsibilities within their home, school, and community.

3. To learn these skills and meet the learning targets, her students would study the Constitution and the Bill of Rights, complete a community citizenship project and explain it in a letter to the teacher, role play to solve a school-based issue, discuss bullying, and study symbols that represent political and cultural ideas.

Figure 2.1 Third-Grade Curriculum Map

Atlas Curriculum Mapping: Unit Map

South Routt School District
Famulare, Courteney/Social Studies 3/Grade 3 (Elementary)

Unit: Citizenship (Week 1, 3 Weeks)

Standards/CSAPs

Social Studies (2009), Third Grade, Civics
Prepared Graduates:
Analyze and practice rights, roles, and responsibilities of citizens.
GLE 1. Respecting the views and rights of others is a key component of a democratic society

 a. Identify and apply the elements of civil discourse including but not limited to listening with respect for understanding and speaking in a respectful manner.

 b. Identify important economic and personal rights and how they relate to others.

 c. Give examples of the relationship between rights and responsibilities.

Prepared Graduates:
Analyze origins, structure, and functions of governments and their impacts on societies and citizens.

 a. Identify the origins, structure, and functions of local government.

 b. Identify and explain the services local governments provide and how those services are funded.

 c. Identify and explain the variety of roles leaders, citizens, and others play in local government.

Essential Questions

- What is community?
- How are communities different?
- What does citizenship mean to you?
- What are our rights and responsibilities?
- Can a child make a difference as a citizen?
- How can you show citizenship?
- What does the U.S. flag represent and what does the pledge mean?

Content	Skills
CitizenshipRights and responsibilities of a citizenBill of Rights and ConstitutionDifferences between the Constitution and third-grade rights and responsibilitiesThree branches of government	Students will be able to demonstrate citizenship within the community.Students will be able to explain why citizenship is important.Students will be able to explain the Bill of Rights.Students will understand their own rights and responsibilities at home, school, and in the community.

Assessment

Unit-Based Summative: Written Test
Students will answer questions demonstrating knowledge.

Unit-Based Summative: Personal Project
Students will complete a community project that demonstrates citizenship and write a letter to their teacher explaining the project and the importance of citizenship.

Formative: Teacher Observation
Teacher will expect participation in the creation and discussion of a classroom Bill of Rights and Constitution.

Formative: Narrative Writing Assignment
Students will write about a time when they felt bullied.

Formative: Narrative Writing Assignment
The students will write about what the world would be like if there were no laws and share their ideas with others.

Formative: Dramatization
Students will work as a group to solve a community issue.

Learning Activities	Resources
• Complete a community citizenship project and explain it in a letter to the teacher • Bullying activities • Citizenship activities • Constitution activities • Participate in role play to solve school-based issues • Study symbols that represent political and cultural ideas	• Citizenship binder • Assessments

SOURCE: Curriculum map developed by C. Famulare of South Routt School District RE3 using Rubicon Atlas Software. Reprinted with permission.

Figure 2.2 Colorado Standard and Grade-Level Expectation Used in Curriculum Map 2.1

Content Area: Social Studies

Standard: 4, Civics

Prepared Graduates: Analyze and practice rights, roles, and responsibilities of citizens	
Grade-Level Expectation: Third Grade	
Concepts and skills students master: 1. Respecting the views and rights of others is a key component of a democratic society	
Evidence Outcomes	**Twenty-First-Century Skills and Readiness Competencies**
Students can a. Identify and apply the elements of civil discourse to include but not limited to listening with respect for understanding and speaking in a respectful manner b. Identify important economic and personal rights and how they relate to others c. Give examples of the relationship between rights and responsibilities	**Inquiry Questions:** 1. Why might an individual make a choice to participate in the community? 2. What are the essential elements of compromise that enable conflict to be transformed into agreement? 3. Why is personal advocacy important in a community with diverse views? 4. What would a community be like if individuals from various groups did not respect each other's rights and views?
	Relevance and Application: 1. Respect for the views of others helps students learn and understand various perspectives, thoughts, and cultures. For example, environmentalists, industry, and government work together to solve issues around energy and other resources. 2. Technology provides the opportunity to research multiple views on issues to better understand the evolution of rights. For example, lawyers research court findings and individuals engage in civic discourse regarding issues of the day through the Internet.
	Nature of Civics: 1. Responsible community members take the opportunity to make positive changes in their community. 2. Responsible community members recognize the value of respecting the rights and views of others.

SOURCE: Colorado Department of Education. Adopted December 10, 2009.

4. Her students' progress toward the understanding of the learning targets would be formatively assessed by

 a. the creation and discussion of a classroom Bill of Rights and Constitution,

 b. having students write about a time when they felt bullied,

 c. having them write about what the world would be like if there were no laws, and

 d. having them work as a group to solve a community issue.

5. Her students' understanding of the learning targets would be summatively assessed by

 a. a written test, and

 b. a letter to the teacher that detailed the importance of citizenship and was supported by a community citizenship project the student completed.

Figure 2.3 is a portion of a curriculum and assessment map outlining the learning targets and assessments for studying the scientific method in a high school biology class. The notation in parentheses references the state standards in science. The teacher team that developed the biology example made the following decisions:

1. All freshmen took biology, and it was important that students understood the scientific method—for success in biology and future science classes and because it was a key standard assessed by the state exam.

2. Applying the scientific method was important enough to be a standards-based learning target for biology.

3. As a learning target, the scientific method was taught to students by direct instruction by the teacher and by lab exercises.

4. Students' understanding of the various components of the scientific method were assessed by

 a. lab results and write-ups formatively and summatively assessed by a common rubric,

 b. class discussion formatively assessed by teachers' professional judgment,

 c. a summative unit test using a common grading scale, and

 d. a common, summative final exam using a common grading scale.

| **Figure 2.3** | Curriculum Map for High School Biology |

Course: Biology

State Standard (11A): Know and apply the concepts, principles, and processes of scientific inquiry.

Materials Used: Biology: Visualizing Life (textbook and workbook), Holt, 2008

Learning Targets	Assessments
1. Explain the difference between hypothesis and fact. (11A)	Lab using formative and summative rubrics Lab write-up Summative common unit test Summative common final
2. Use the following steps for laboratory experimentation: define the problem, collect information, form a hypothesis, experiment to test the hypothesis, observe and record data, and draw a conclusion. (11.A4a-11A4f, 13A4b, 13 A4d)	Lab using formative and summative rubrics Lab write-up Summative common unit test Summative common final
3. Describe how to set up a controlled experiment. (11A4b)	Lab using formative and summative rubrics Class discussion Summative common unit test Summative common final

| **Figure 2.4** | Illinois Science Standards Used in Curriculum Map 2.3 |

STATE GOAL 11: Understand the processes of scientific inquiry and technological design to investigate questions, conduct experiments, and solve problems.

Why This Goal Is Important: The inquiry process prepares learners to engage in science and apply methods of technological design. This understanding will enable students to pose questions, use models to enhance understanding, make predictions, gather and work with data, use appropriate measurement methods, analyze results, draw conclusions based on evidence, communicate their methods and results, and think about the implications of scientific research and technological problem solving.

A. Know and apply the concepts, principles, and processes of scientific inquiry.

Early Elementary	Late Elementary	Middle/Junior High School	Early High School	Late High School
11.A.1a Describe an observed event.	11.A.2a Formulate questions on a specific science topic and choose the steps needed to answer the questions.	11.A.3a Formulate hypotheses that can be tested by collecting data.	11.A.4a Formulate hypotheses referencing prior research and knowledge.	11.A.5a Formulate hypotheses referencing prior research and knowledge.

Early Elementary	Late Elementary	Middle/Junior High School	Early High School	Late High School
11.A.1b Develop questions on scientific topics.	**11.A.2b** Collect data for investigations using scientific process skills including observing, estimating, and measuring.	**11.A.3b** Conduct scientific experiments that control all but one variable.	**11.A.4b** Conduct controlled experiments or simulations to test hypotheses.	**11.A.5b** Design procedures to test the selected hypotheses.
11.A.1c Collect data for investigations using measuring instruments and technologies.	**11.A.2c** Construct charts and visualizations to display data.	**11.A.3c** Collect and record data accurately using consistent measuring and recording techniques and media.	**11.A.4c** Collect, organize, and analyze data accurately and precisely.	**11.A.5c** Conduct systematic controlled experiments to test the selected hypotheses.
11.A.1d Record and store data using available technologies.	**11.A.2d** Use data to produce reasonable explanations.	**11.A.3d** Explain the existence of unexpected results in a data set.	**11.A.4d** Apply statistical methods to the data to reach and support conclusions.	**11.A.5d** Apply statistical methods to make predictions and to test the accuracy of results.
11.A.1e Arrange data into logical patterns and describe the patterns.	**11.A.2e** Report and display the results of individual and group investigations.	**11.A.3e** Use data manipulation tools and quantitative (e.g., mean, mode, simple equations) and representational methods (e.g., simulations, image processing) to analyze measurements.	**11.A.4e** Formulate alternative hypotheses to explain unexpected results.	**11.A.5e** Report, display, and defend the results of investigations to audiences that may include professionals and technical experts.
11.A.1f Compare observations of individual and group results.		**11.A.3f** Interpret and represent results of analysis to produce findings.	**11.A.4f** Using available technology, report, display, and defend to an audience conclusions drawn from investigations.	

SOURCE: Illinois State Board of Education, 1997, pp. 46–49.

When aligning curriculum and assessments to targets and standards, it is important for you or your team to stay focused on the targets and standards. As teachers, most of us are highly engaged with the content we teach. It is easy for us to lose focus and thus overteach one standard and forget another. It also is common for new topics to be added to the curriculum but never be assessed. Therefore, teacher teams need to be disciplined about having both the curriculum and the assessments reflect the learning targets they believe are important for students to know and be able to do.

When you have aligned your curriculum and assessments to learning targets, the analyzed results of your formative and summative assessments will tell you which learning targets your students have mastered and which ones they're struggling with. Because the test data are directly aligned to the learning targets, you will harness the power that comes from knowing what your students have learned. Knowing exactly what you need to do next to help your students be more successful will energize your teaching, and your students will be motivated to do better because they will see a pathway toward improvement. You will be empowered as a teacher, and your students will be empowered as learners. This will make a difference in your students' lives as well as your own.

Figure 2.5 Creating a Data-Driven Instructional System: A Cyclical and Recursive Process

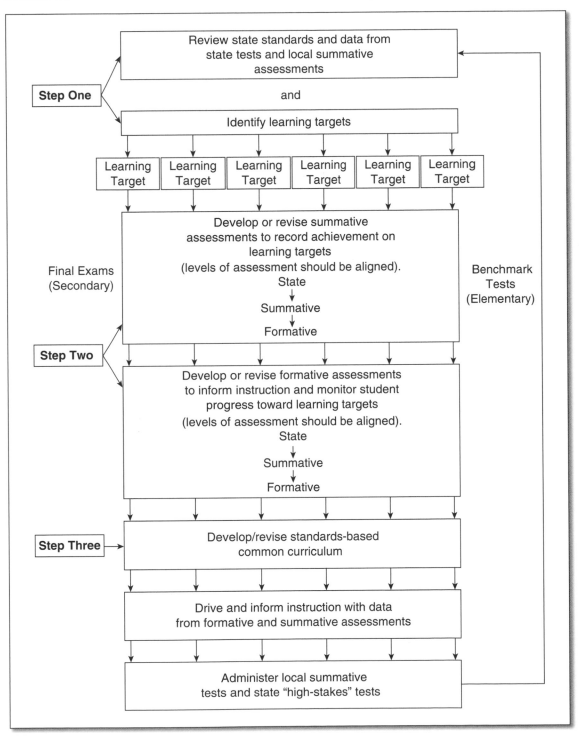

(Notes for this figure can be found on the following page.)

Figure 2.5	(Continued)

Notes:

1. Developing a data-driven instructional system complete with standards-based formative and summative assessments and a standards-based curriculum takes time. Don't try to develop all of the components of the system outlined in the diagram in one school year. Begin the process by developing learning targets and summative assessments for the subjects that are most important—whatever the reason. If you try to develop all the components of the system in one school year, you will be overwhelmed and feel defeated. Begin with learning targets and assessments, and start collecting and analyzing data. You will be motivated by the power of data analysis and energized and eager to do more.

2. Creating a data-driven instructional system is a process that is both cyclical and recursive. Before school begins in the fall, develop your learning targets, assessments, and curriculum for a particular subject area. As the school year progresses, teach your students, formatively assessing along the way to inform your instruction and chart student progress and summatively assessing to document achievement. In the spring, students will take the state mandated high-stakes test.

 When you receive the state test scores in the summer or early fall, the cycle begins again. The process is recursive because based on state test results, you will revise your assessments and curriculum and your teaching strategies. For the most part, these "revisions" will be minor adjustments to your previous work.

3. A data-driven instructional system can be created by an individual teacher, a grade or subject team, or an entire school. Regardless of the number of teachers involved in the process, gathering and analyzing data and using the results of data analysis is the most important part of the process. Even if you're only able to identify and assess one or two learning targets, using data is what will transform your teaching and give you a new sense of power and control.

Chapter Two Rubric: Creating a Data-Driven Instructional System

	Not Yet	In Progress	Completed
Step One: Define Learning Targets.			
1. I/we have reviewed state standards and state assessment results to determine "key" standards based on the level of difficulty and the number of test items.			
2. I/we have reviewed state standards and state assessment results to determine "key" standards based on areas where our students have low scores.			
3. I/we have identified key standards-based learning targets.			
Step Two: Align Learning Targets and Assessments.			
4. I/we have written formative and summative assessments that are aligned with my standards-based learning targets.			
5. My/our formative assessments provide useful data regarding what my students do and do not know. They inform my practice.			
6. My/our summative assessments provide data useful in assessing learning targets, teaching methods, and instructional materials.			
7. My/our assessments have been piloted to eliminate bias and poor questions and to maximize alignment with learning targets.			
Step Three: Align Learning Targets and Curriculum.			
8. I/we have collected materials and information to document what is currently being taught in each grade level and subject area.			
9. I /we have compared what is currently being taught with our standards-based learning targets and have identified gaps and redundancies in the currently taught curriculum.			
10. I/we have revised the currently taught curriculum to eliminate gaps and redundancies.			
11. I/we have linked our new, local curriculum to standards. All key standards are addressed in the new, revised curriculum.			
12. I/we have examined horizontal alignment and pacing issues. All teachers at a given grade level are following the new common curriculum.			
13. I/we have examined vertical alignment so that courses build and prepare students for what is to follow. Vertical gaps and redundancies have been eliminated.			

(Continued)

(Continued)

Reflections

Ways this chapter has changed my thinking:

1.

2.

Next steps:

1.

2.

3

Making Data-Driven Decisions in the Classroom

Data-driven instruction is powered by the consistent use of formative classroom assessments that are quickly scored and analyzed to provide teachers with the data to inform instruction. Formative assessments assess what our students have learned by using products and tests that are aligned with standards-based learning targets and curricula. Frequently, formative assessments are teacher-created criterion-referenced tests (CRTs) that are used on a regular basis to measure student progress toward identified learning targets. However, formative assessments also include quizzes, writing samples, labs, speeches, and anything that focuses on a clear target and tells us if our students are "getting it."

Formative assessments improve teaching and learning because they help make our students' thinking and learning visible to us as our students progress through instruction. Formative assessments give us feedback about our students' thinking and provide opportunities for us to revise instruction by making moment-by-moment decisions based on our ongoing assessments of our learners' current levels of understanding (Bransford, Derry, Berliner, Hammerness, & Beckett, 2005).

Unless we actively monitor our students' learning, we may think our students have learned something when they haven't. Have you

ever heard a colleague say, "I taught it; they just didn't learn it"? The ability to monitor our students' understanding is not simply a general skill; it requires knowledge of different levels and types of formative assessments that help us determine the discrepancies between what our students currently understand and what they need to know.

As we progress with instruction, formative assessments also help us provide our students with challenges that are just the right level of difficulty—not so easy that they are boring and not so difficult that they are frustrating. Creating the right kinds of "just manageable difficulties" for our students constitutes one of our major challenges and "requires expert juggling acts" (Bransford et al., 2005, p. 61). Formative assessments help us to motivate and challenge our students as we carefully and efficiently guide them toward their understanding of learning targets.

The use of formative assessments can be viewed as a continuum of opportunities for teachers—from opportunities to make micro-adjustments to mid-lesson teaching to opportunities to make macro-adjustments to both curriculum and instruction. Tom Guskey correctly summarized the use of formative assessments when he said, "For assessments to become an integral part of the instruction process, teachers need to 1) use assessments as sources of information for both students and teachers, 2) follow assessment with high-quality corrective instruction and 3) give students second chances to demonstrate success" (2007, p. 16).

Using Formative Assessment Data to Immediately Inform Teaching

Good teachers are constantly assessing their students while they are engaged in the act of teaching them. Most of us can easily identify boredom or engagement with a topic just by looking at the faces of our students. There are, however, numerous other strategies we use to quickly learn if our students are understanding the lesson. Carefully distributed questions that check for understanding are a proven way to know whether or not students are with us. Questions help us to diagnose readiness, make instructional decisions, and evaluate comprehension. This is an informal mode of monitoring and assessing and is an integral part of instruction.

Our assessment questions reveal to us what our students have learned, their level of comprehension, and the abilities of our students to use and apply new knowledge. Our students' answers

help us make decisions about the pace of instruction, when to review, when to provide more practice, and when to move ahead. When we think about moving ahead, we use questions to diagnose student readiness for a new task and to determine how well prior learning targets have been met. Student interest and motivation to learn a new topic can also be assessed with carefully structured questions (Bellon, Bellon, & Blank, 1992).

While good teachers possess uncanny abilities to sense whether or not their students are "getting it," assessment-powered teachers are more analytical about what their students know and what they don't know and develop systems for recording the results of their teaching and their students' learning. In addition to using carefully structured questioning strategies, recent technology provides teachers with numerous resources to easily and quickly know if students are with them.

Bobbi Korte, an eighth-grade geography teacher in Redlands, California, uses technology to give her the ability to administer mid-lesson quizzes and have students respond to her questions by using a remote clicker to select an answer. Bobbi states:

> Teaching geography and map-making skills are rarely greeted with cheers, but in my eighth-grade classes, that is what I hear. What is the difference? I use a combination of Interwrite School Pads and RF clickers that turn the map lesson into interactive classroom fun. This method can be generalized to any grade level and most content lessons—even grammar!

Bobbi goes on to say,

> Teachers are asked to do so much these days that short, formative assessments and reteaching are the ONLY way to go. The clickers and school pad are tools that I have found that allow me to do this. In addition, the use of this new technology has re-energized my teaching and my student's excitement for learning. Can you imagine students asking to take a quiz? Mine do! The ancillary learning to read/interpret a graph is icing on this cake. (personal communication, February, 2009)

There are a variety of products that can provide teachers with instant feedback on mid-lesson questioning. In most cases teachers develop questions around a slide. Bobbi used a slide of a map. Then they choose a question type (multiple choice, true/false, rating scale, multiple mark, numeric-fraction/decimal/sequencing, or short-answer completion), decide how many points to assign to each question, and decide the time allowed to students to answer the question.

Students answer the questions with remote response clickers and their answers are immediately analyzed and converted into graphs to allow everyone in the classroom to view the results.

The use of clickers promotes assessment-powered teaching by giving teachers immediate feedback on students' understanding and providing specific information to make mid-lesson adjustments to instruction. Using the clickers makes it possible to formatively assess all students, as even students who normally remain silent answer questions without fear of embarrassment. When the interactive questioning session is over, analyzed results can be saved for review, differentiated instruction, or future reteaching.

Using Formative Assessment Data to Inform Teaching Over Time

As teachers, we also are concerned about whether or not our students understand information, concepts, and processes that may be taught in multiple lessons. Here we often use a quiz or chapter test to assess what our students know and don't know. Rather than merely grading the quiz and recording the grade, it is key that the quiz or test results be analyzed so that interventions and reteaching can occur while the unit is still being taught. Looking at data from our own classroom assessments serves as a meaningful source of information because it provides us with specific guidance to improve the quality of our teaching by helping us identify what we taught well and what needs work (Guskey, 2007).

Gathering the vital information from classroom assessments can be done "by hand" by making a "simple tally of how many students missed each item on the assessment or failed to meet a specific criterion" (Guskey, 2007, p. 18). However, most teachers would find this unnecessary when so much simple, useful technology is already available in our schools to score, analyze, and record data. The time and effort of doing data analysis by hand only adds yet another burden to the job of teaching and generally is discouraging to the use of formative assessments, and the value that comes with the use of formative assessment data often dies with the weight of hand scoring.

In reflecting on the ease and efficiency of electronic scoring, Kipp Rillos, a vocational business teacher in northwest Colorado, states,

Automating [the scoring and data analysis] component of the grading significantly decreases the aggregate grading time required, decreasing the time from when the student takes the

assessment to when they receive their graded exam. As an instructor this also decreases my grading fatigue and allows me to provide better feedback on elements of the assessment that are more qualitative in nature like extended response or essay type questions. (personal communication, April 2010)

Fortunately, an abundance of technology is available to teachers that makes the use and scoring of formative assessments simple, practical, and cost-effective. Most schools have scanners for scoring tests and quizzes. If quiz and test questions are organized on the test or quiz by learning target, it's easy for teachers to see which targets students know and which are not being understood by students.

La Cheri Rennick teaches sixth-, seventh-, and eighth-grade science in a small private school in Palm Springs, California. To check for her seventh graders' understanding of the learning targets of mitosis and the cell cycles, she gave a short twenty-question mini-quiz. Had the results been recorded, there would have been six As (100–90%), eight Bs (89–80%), three Cs (79–70%), nine Ds (69–60%), and eight Fs. After giving this formative assessment, she "decided there needed to be some intervention."

She states,

What I noticed was that the majority of the students missed the phases of mitosis. I retaught the lesson using manipulatives. We used a mitosis flip book where students drew the phases and labeled each phase. The students then looked at mitosis through the microscope and drew the phases they saw. I also had the students do a mitosis adventure on the Internet. With all the visuals, I knew the students would do better. I retested with another mini-quiz on the concept of mitosis and cell cycle and the grades were as follows: fifteen As, eleven Bs, six Cs, one D and one F. The student that got the F was on extended leave and wasn't in class for the lesson. The D student is autistic. (personal communication, November 2008)

By aligning her quiz to specific learning targets, La Cheri quickly determined that her students didn't understand the phases of mitosis, even though she taught it. By formatively assessing her students' learning, she was able to remedy the weakness before moving on.

Many teachers use scanners to score their tests but fail to organize their tests by learning target or standard so that the results can easily be analyzed. This simple step of organizing questions by learning target or standard provides valuable information that doesn't require teacher time to tally results. If your school doesn't have a

scanner, you should know that many scanning companies offer scanners free to schools with the purchase of the scanner-specific answer sheets.

Figure 3.1 is an example of an answer sheet for a fifty-question chapter test covering five Illinois Early High School Geography standards. The example test is organized so that six to ten questions test each of the five standards. After the answer sheets are scanned, it is easy for the teacher to see which standards students have understood and which they have not. Often, teachers will use the same number of questions for each standard, making analysis even easier. (Questions 1–5 test learning target 1, questions 6–10 test learning target 2, and so on.)

In any event, it is fairly easy to see that students struggled with questions 1 through 6, which tested Illinois Learning Standard 17A.4a "Use mental maps of physical features to answer complex geographic questions (e.g. land use, ecological concerns)." Notice that 10 out of 22 students missed question 4, and 15 out of 22 students missed question 6. These same students did much better on questions 7 through 18, which tested Illinois Learning Standard 17A.4b "Use maps and other geographic instruments and technologies to analyze spatial patterns and distributions on earth" (Illinois State Board of Education, 1997).

In looking at test results such as these, it is important to go beyond the numbers and consider why students were successful or not. While students may have had a good understanding of common physical features, they may have been challenged by the vocabulary in the answer choices of question 4, which included the terms isthmus, archipelago, and plateau. As Doug Reeves (2008) states,

> The essence of a successful discussion about data is a commitment to examine not only the data, but also the stories behind the numbers. Only when we can articulate the "why" behind the data and turn the lens on our own teaching and leadership behaviors can we understand how to move from drowning in data to improving professional practice. (p. 90)

In addition to simply using scanners, many programs are available to schools that score tests and report the results to teachers by curriculum objective, learning target, or state standard. Many of these programs are cost-effective, as a number of textbook publishers offer test-generating programs in which teacher-made or item-bank questions can be aligned with state standards and then linked with software to generate reports that track student progress toward learning

Figure 3.1 Scantron Item Analysis

targets and standards and identify areas that may need remediation or additional instruction (see, for instance, eInstructionExamView, at www.einstruction.com).

Kipp Rillos believes that the detailed and automated reporting of student performance by standard "allows for better remediation on an individual level with the student and for identification of subject areas requiring additional coverage at the class level" (personal communication, April 2010). Kipp was the first teacher in his school to use automated test analysis provided with his textbook, but due to the information he gained from test analysis as well as the availability and efficiency of this method, other teachers in his building and district are now using it too.

Benchmark Assessments

In tracking student progress over time, such as a grading period or a semester, schools often give benchmark assessments or final exams. Rather than merely collecting the data, effective schools, teachers, and teacher teams use data to develop macro-interventions, such as changing the pacing of a class or changing curriculum materials used. Benchmark assessments are common assessments in that all teachers of a particular grade or subject give the same test at approximately the same time. The use of common benchmark assessments helps to enhance student achievement for all students, because data from common assessments help teachers identify students' strengths and weaknesses and thus provide specific macro-interventions to remediate the weaknesses.

Benchmark assessments often serve the purpose of being both formative and summative. They are summative assessments in that they may serve as a quarter or semester exam and receive a grade. The same benchmark assessment also may be a formative assessment in that it provides information to teachers and administrators on how a student or group of students is progressing toward meeting state standards. Often, benchmark assessments predict how students will fare on a high-stakes state assessment or graduation test, providing teachers the opportunity to remediate any weaknesses before the student actually takes the high-stakes test.

Some schools purchase benchmark tests from testing companies or textbook publishers that have taken steps to align benchmark assessments with various state standards and also provide schools with score reports that align student scores with state standards.

Some Chicago public schools, for example, give benchmark assessments that are standardized measures of basic skills, including reading, early literacy, early numeracy, and math. The use of curriculum-based measurement is a research-based method to identify reliable and valid ways to assess students' progress in the basic skills areas. With handheld Palm Link applications, teachers load assessments and student rosters onto their handheld devices, select a student and a measure, and then administer and score the test directly on the handheld device by simply marking errors on the screen. Scores are calculated automatically and stored. The software eliminates hand data entry, manual score calculation, and scoring on paper. These teachers capture their students' test data and upload them for quick, accurate, and efficient scoring.

Desert Sands Unified School District in California develops local common benchmark assessments by using teams composed of an assessment coordinator and grade-level teacher teams. Test items are selected from a publisher item bank, and test drafts are reviewed and revised by grade-level teams. After benchmark tests are administered to students, teacher teams meet and review data from the locally scored tests and decide on next steps using data protocol sheets. (See Chapter 6 for more information.)

Other school districts, such as DuPage High School District 88 near Chicago, build their own benchmark assessments by using subject teams that decide the method of assessment and then write questions that align with the standards and learning targets of their teacher-written common curriculum. (See Sindelar, 2006, for further discussion of how to write local benchmark assessments.)

Figure 3.2 is an example of a test analysis report for multiple learning targets for a class of 23 algebra students. The test is a common final exam written by the algebra teacher team in the school. By looking at this item analysis by learning target report, the teacher can see how students in this class are progressing toward meeting the various learning targets or standards taught. Note that the specific learning target embedded within the Illinois Learning Standards is included in parentheses under the learning target. This report shows results by grouping test questions by learning target and the correct answer for each question, as well as the percentage of students selecting each answer. This report is extremely useful in determining which of the learning targets students have learned and which they have not. If an entire class scores poorly on a particular target, then the teacher knows to reteach the learning target before moving on to new material.

Figure 3.2 Item Analysis for One Class

Standard Item Analysis for 23 Students	Course Objective For* Jun 00 M11/1272 ESS Of Algebra
08/07/2000 1999–2000 School Year	Course Objectives For ESS Algebra

M1173—06: Solve problems involving percents and proportions.

(S.6.D.4, S.7.C.4b, S.9A4a, S.10A4a)

Item	A	B	C	D	E	Space
#52 -	22 (96%)*	1 (4%)	0 (0%)	0 (0%)	0 (0%)	0 (0%)
#53 -	2 (9%)	3 (13%)	7 (30%)	11 (48%)*	0 (0%)	0 (0%)
#54 -	0 (0%)	3 (13%)	18 (78%)*	2 (9%)	0 (0%)	0 (0%)
#55 -	3 (13%)	14 (61%)*	2 (9%)	4 (17%)	0 (0%)	0 (0%)
#56 -	2 (9%)	2 (9%)	2 (9%)	17 (74%)*	0 (0%)	0 (0%)
#57 -	0 (0%)	2 (9%)	21 (91%)*	0 (0%)	0 (0%)	0 (0%)
#58 -	14 (61%)*	1 (4%)	1 (4%)	7 (30%)	0 (0%)	0 (0%)
#59 -	1 (4%)	21 (91%)*	1 (4%)	0 (0%)	0 (0%)	0 (0%)
#60 -	15 (65%)*	3 (13%)	3 (13%)	2 (9%)	0 (0%)	0 (0%)
#61 -	3 (13%)	9 (39%)*	8 (35%)	3 (13%)	0 (0%)	0 (0%)
#62 -	2 (9%)	4 (17%)	17 (74%)*	0 (0%)	0 (0%)	0 (0%)
#63 -	13 (57%)*	3 (13%)	5 (22%)	1 (4%)	0 (0%)	1 (4%)
#64 -	0 (0%)	4 (17%)	9 (39%)	10 (43%)*	0 (0%)	0 (0%)
#65 -	4 (17%)	2 (9%)	16 (70%)*	1 (4%)	0 (0%)	0 (0%)
#66 -	6 (26%)	17 (74%)*	0 (0%)	0 (0%)	0 (0%)	0 (0%)

M1173—08: Solve word problems by writing and solving an equation.

(S.6.B.4, S.6.C.4)

Item	A	B	C	D	E	Space
#43 -	0 (0%)	22 (96%)*	0 (0%)	1 (4%)	0 (0%)	0 (0%)
#44 -	2 (9%)	0 (0%)	3 (13%)	18 (78%)*	0 (0%)	0 (0%)
#45 -	6 (26%)	15 (65%)*	1 (4%)	1 (4%)	0 (0%)	0 (0%)
#46 -	2 (9%)	6 (26%)	10 (43%)	6 (26%)*	0 (0%)	0 (0%)
#47 -	14 (61%)*	2 (9%)	2 (9%)	5 (22%)	0 (0%)	0 (0%)
#48 -	2 (9%)	2 (9%)	18 (78%)*	1 (4%)	0 (0%)	0 (0%)
#49 -	13 (57%)*	2 (9%)	4 (15%)	5 (19%)	0 (0%)	0 (0%)
#50 -	2 (9%)	2 (9%)	14 (61%)*	4 (17%)	0 (0%)	1 (4%)
#51 -	2 (9%)	7 (30%)	12 (52%)*	2 (9%)	0 (0%)	0 (0%)

M1173—10: Graph linear equations in two variables.

(S.8.C.4a, S.8.D.4, S.9.B.4)

Item	A	B	C	D	E	Space
#20 -	1 (4%)	16 (70%)*	4 (17%)	1 (4%)	0 (0%)	1 (4%)
#21 -	2 (9%)	0 (0%)	14 (61%)*	5 (22%)	0 (0%)	2 (9%)
#22 -	1 (4%)	1 (4%)	15 (65%)*	6 (26%)	0 (0%)	0 (0%)
#23 -	17 (74%)*	3 (13%)	0 (0%)	2 (9%)	0 (0%)	1 (4%)
#24 -	0 (0%)	3 (13%)	0 (0%)	20 (87%)*	0 (0%)	0 (0%)
#25 -	1 (4%)	18 (78%)*	0 (0%)	4 (17%)	0 (0%)	0 (0%)
#26 -	2 (9%)	5 (22%)	2 (9%)	14 (61%)*	0 (0%)	0 (0%)
#27 -	1 (4%)	0 (0%)	1 (4%)	21 (91%)*	0 (0%)	0 (0%)

SOURCE: Created using the Assessor by Progress Education at DuPage High School District 88, Villa Park, IL., 2000. From *Using Test Data for Student Achievement: Answers to No Child Left Behind* (pp. 65–66), by N. W. Sindelar, 2006, Lanham, MD: Rowman and Littlefield. Copyright 2006 by Nancy W. Sindelar. Reprinted with permission.

This report also points out particular questions that were difficult for students. For example, only 26%, or 6 of the 23 students, answered question 46 correctly. Is it a poorly written question or was information presented that made 43% of the students believe "C" was the correct answer? Certainly, these are questions the teacher would want to answer before the class moves on to the next unit.

Maureen Lyons, a seasoned math teacher in the district, has used this type of analysis for years. She states,

> I look at the final exam results to see which questions were missed the most and try to figure out why. Sometimes it's the wording or the form of the answers (different ways we write the same number or expression). I also analyze which questions were too easy and make a decision to keep or discard them on future exams. This data does help me plan my lessons for next year/next chapter/next semester, including my actual teaching *in* the classroom. (personal communication, July 2007)

The assessment software program used in this report also provides teachers with alphabetical student results, which lists a class or group of students alphabetically by name, tells the number of questions answered correctly, and assigns a grade, based upon the grading scale set by a teacher or teacher team (see Figure 3.3). Another useful report is the Standard Mastery Report (Figure 3.4), which shows the number and percentage of students exceeding, meeting, or not meeting a particular learning target or standard.

While testing companies have taken steps to align assessments with various state standards and are also providing schools with score reports that align student scores with state standards, my experience has been that we, as teachers, do not always believe that tests developed outside our schools are testing what is really taking place in our classrooms, and, therefore, we may not be as invested in the results provided in the reports.

I believe a better path to take is to have teacher teams write their own assessments aligned to their previously identified learning targets and state standards. The benefits of this process include rich discussions about what students should know and how we as teachers will know if they know it. While the locally developed tests are more work for teachers and perhaps initially more expensive for the district, the end result is that teachers "own" the tests and the results and feel committed to helping their students reach the learning targets they have set and measured.

Figure 3.3	Alphabetical Student Results With Grade

Alphabetical Student Results JUN 00M11/1272 ESS OF ALGEBRA : 71/0 FCP ITEMS
08/07/2000 1999–2000 School year ESS ALGEBRA 1–3–1

Student Name	Performance	Forced Choice	Total	Grade
Carlos, Juan	0 of 0	54 of 71	76	76% C
Davis, Sally	0 of 0	47 of 71	66	66% D
Ease, Linda	0 of 0	64 of 71	90	90% A
Edwards, Jennifer	0 of 0	49 of 71	69	69% D
Force, Jennifer	0 of 0	53 of 71	75	75% C
Gates, Henry	0 of 0	55 of 71	77	77% C
Gregory, Russell	0 of 0	59 of 71	83	83% B
Hicks, Joseph	0 of 0	57 of 71	80	80% B
Jones, Abby	0 of 0	47 of 71	66	66% D
King, Daniel	0 of 0	60 of 71	84	84% B
Layne, Nicole	0 of 0	56 of 71	79	79% C
Lowe, Irma	0 of 0	52 of 71	73	73% C
Monroe, Ray	0 of 0	43 of 71	61	61% D
Moses, Javier	0 of 0	51 of 71	72	72% C
Nance, William	0 of 0	55 of 71	77	77% C
Norris, Leticia	0 of 0	57 of 71	80	80% B
Olsen, Monica	0 of 0	40 of 71	56	56% F
Pope, Melissa	0 of 0	52 of 71	73	73% C
Royce, Joe	0 of 0	50 of 71	70	70% C
Smith, Paul	0 of 0	22 of 71	31	31% F
Tate, Ronda	0 of 0	43 of 71	61	61% D
Todd, Angelica	0 of 0	49 of 71	69	69% D
Wilson, Betty	0 of 0	36 of 71	51	51% F
23 Student Average	0 of 0	50 of 71	70	70% C

SOURCE: Created using the Assessor by Progress Education. From *Using Test Data for Student Achievement: Answers to No Child Left Behind* (p. 64), by N. W. Sindelar, 2006, Lanham, MD: Rowman and Littlefield. Copyright 2006 by Nancy W. Sindelar. Reprinted with permission.

Assessment-Powered Teaching

Figure 3.4 Item Analysis by Learning Target/Standard for All Algebra Students

Standard Mastery Report 12/13/2006 2006–2007					ALG 9 SEMI Final MA1206–1 Algebra					
	Forced Choice Mastery				**Performance Mastery**				**Total Mastery**	
Perform operations on real numbers										
→ Exceeds	92	75%	(8 of 10)	80%	0	0%	(0 of 0)	80%	92	75%
→ Meets	0	0	(6 of 10)	60%	0	0%	(0 of 0)	60%	0	0
→ Does Not Meet	31	25%	(< 6)		0	0%	(< 0)		31	25%
☺ MA1206–1	(75%)	(92 of 123 have mastered this COURSE OBJECTIVE)								
Perform operations on algebraic expressions										
→ Exceeds	56	45%	(27 of 34)	80%	0	0%	(0 of 0)	80%	56	45%
→ Meets	49	40%	(20 of 34)	60%	0	0%	(0 of 0)	60%	49	40%
→ Does Not Meet	18	15%	(< 20)		0	0%	(< 0)		18	15%
☺ MA1206–1	(85%)	(105 of 123 have mastered this COURSE OBJECTIVE)								
Solve equations in one variable										
→ Exceeds	64	52%	(8 of 10)	80%	0	0%	(0 of 0)	80%	64	52%
→ Meets	33	27%	(6 of 10)	60%	0	0%	(0 of 0)	60%	33	27%
→ Does Not Meet	26	21%	(< 6)		0	0%	(< 0)		26	21%
☺ MA1206–1	(79%)	(97 of 123 have mastered this COURSE OBJECTIVE)								
Use linear relationships to solve problems										
→ Exceeds	40	33%	(9 of 11)	80%	0	0%	(0 of 0)	80%	40	33%
→ Meets	37	30%	(7 of 11)	60%	0	0%	(0 of 0)	60%	37	30%
→ Does Not Meet	46	37%	(< 7)		0	0%	(< 0)		46	37%
☺ MA1206–1	(63%)	(77 of 123 have mastered this COURSE OBJECTIVE)								
Overall Pass/Fail										
→ Exceeds	55	45%	(8 of 10)	80%	0	0%	(0 of 0)	80%	55	45%
→ Meets	42	34%	(6 of 10)	60%	0	0%	(0 of 0)	60%	42	34%
→ Does Not Meet	26	21%	(< 6)		0	0%	(< 0)		26	21%
☺ MA1206–1	(79%)	(97 of 123 have mastered this COURSE OBJECTIVE)								

SOURCE: Created using the Assessor by Progress Education at DuPage High School District 88, Villa Park, IL. Reprinted with permission.

Test Reports

While there are a variety of ways benchmark assessments can be developed, the power to teachers comes from using the data that are provided by the testing. It is the data from benchmark assessments that initiate the macro-changes in curriculum, pacing, and sometimes even scheduling of classes, and these are the changes that can have a huge impact on student achievement.

Figures 3.5 and 3.6 are reports for standardized measures of basic skills for second graders and chart student progress in these basic skills rather than specific standards. Figure 3.5 is a class report for second-grade math students. These students have taken a normed test, which compares the individual student to a nationally normed group, a random sample of students chosen by the test developer to establish an average score. The second-grade students are then ranked according to how well they did in relation to the norm group by being given a percentile score. Based on the percentile score, recommendations for "potential instruction action" are given to the teacher. Figure 3.6 reports an individual second grader's progress across two academic years, the total time the student's been in school.

Figure 3.7 is the analysis of a teacher-developed benchmark math assessment for a seventh-grade class. The test report shows the results of a teacher-developed criterion-referenced test (CRT), which measures students' progress toward North Carolina's math standards. The standards are listed on the left and the proficiency for a class of ten students is listed on the right. It's easy for a teacher or teacher team to see that students, though doing well overall, are having difficulty with measurement. This report would prompt examination of the textbook, discussion of a need for measurement manipulatives and other resources or strategies to help the students improve their understanding of measurement.

While all the reports in this book contain an abundance of helpful data, they are only the beginning and not the end of using test data to improve instruction. We must remember that the power we gain from assessment is the *use* of assessment data to improve our students' learning by informing and changing our instruction. Though software programs produce reports and graphs in a timely manner, the reports are not the end product. Rather, they are the road maps for us to plan and implement our interventions and the means for us to help our students understand what they need to do next to become more successful.

Figure 3.5 Class Report for 12 Second-Grade Students

AIMSweb Training (SAMPLE DATA)
Year: 2009-2010

FILTER:

Demographics: Not filtering on demographics
Comparison: Report Test School 1
Recommendation Rules: Norm Referenced - 5 Recommendations
Reporting Method: AIMSweb Defaults - Norm Referenced
MCAP - 10,25,75,90 percentile calculated at the school level
M-CBM - 10,25,75,90 percentile calculated at the school level

District: Report Test District 1
School: Report Test School 1
Date: Spring - 2009-2010
Grade: 2

Grade 2 Mathematics Scores & Instructional Recommendations

MCAP is not shown because there are no scores entered for this measure.

UID	Student	M-CBM Score	M-CBM Percentile Rank/ Comparison	Instructional Recommendations
325463	Cepeda, FRANK	125.0	> 99/ > 99	Well Above Average - Consider Need for Individualized Instruction
384649	Ortiz, DIANNE	115.0	90.0/ 90.0	Well Above Average - Consider Need for Individualized Instruction
834669	Davis, DAVID	103.0	80.0/ 80.0	Above Average - Consider Need for Individualized Instruction
618847	Gorham, ELEANOR	100.0	70.0/ 70.0	Average - Continue Current Program
428683	Younts, CRYSTAL	95.0	60.0/ 60.0	Average - Continue Current Program
158422	Leak, NAOMI	80.0	50.0/ 50.0	Average - Continue Current Program
737614	Foltz, BRIDGET	55.0	40.0/ 40.0	Average - Continue Current Program
911799	Clack, CAROLINE	49.0	30.0/ 30.0	Average - Continue Current Program
832772	Miller, RICHARD	32.0	20.0/ 20.0	Below Average - Further Assess and Consider Individualizing Program
337246	Ballesteros, SAMANTHA	20.0	10.0/ 10.0	Below Average - Further Assess and Consider Individualizing Program
679399	Smith, JAMES	11.0	< 1/ < 1	Well Below Average - Begin Immediate Problem Solving
214843	Lee, JASON	—	—	Unable to determine a recommendation

71.4 Grade Mean

▮ Well Below Average ▮ Below Average ▢ Average
▢ Above Average ▢ Well Above Average

Recommendations generated using Norm Referenced - 5 Recommendations rules.

Figure 3.6 Mathematics Improvement Report for One Student

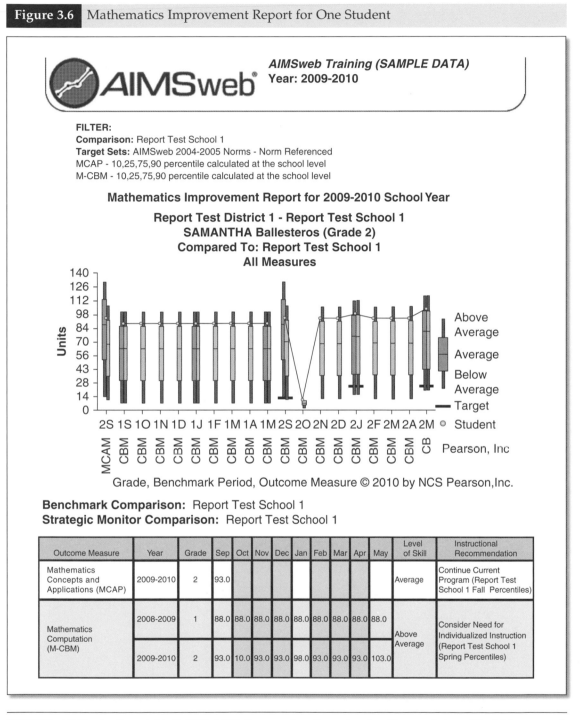

AIMSweb Training (SAMPLE DATA)
Year: 2009-2010

FILTER:
Comparison: Report Test School 1
Target Sets: AIMSweb 2004-2005 Norms - Norm Referenced
MCAP - 10,25,75,90 percentile calculated at the school level
M-CBM - 10,25,75,90 percentile calculated at the school level

Mathematics Improvement Report for 2009-2010 School Year

Report Test District 1 - Report Test School 1
SAMANTHA Ballesteros (Grade 2)
Compared To: Report Test School 1
All Measures

Grade, Benchmark Period, Outcome Measure © 2010 by NCS Pearson, Inc.

Benchmark Comparison: Report Test School 1
Strategic Monitor Comparison: Report Test School 1

Outcome Measure	Year	Grade	Sep	Oct	Nov	Dec	Jan	Feb	Mar	Apr	May	Level of Skill	Instructional Recommendation
Mathematics Concepts and Applications (MCAP)	2009-2010	2	93.0									Average	Continue Current Program (Report Test School 1 Fall Percentiles)
Mathematics Computation (M-CBM)	2008-2009	1	88.0	88.0	88.0	88.0	88.0	88.0	88.0	88.0		Above Average	Consider Need for Individualized Instruction (Report Test School 1 Spring Percentiles)
	2009-2010	2	93.0	10.0	93.0	93.0	98.0	93.0	93.0	93.0	103.0		

Figure 3.7	Proficiency Report for Seventh-Grade Math Class

Class Proficiency Report

Instructor: Leena Malachowski Total Possible: 30 Student Score: 25.7 - 85.67%

Exam Name: Math 2nd Period Highest Score: 30 - 100.00% Class Average: 25.5 - 85.00 %

Exam Date: Monday, July 25, 2005 Lowest Score: 22 - 73.33% Class Size: 10

Proficiency: >=75%

Standard	Description	Students Proficient	%	
Numbers and Operations				
Math 1	Number Sense: Understands numbers, ways of representing numbers, relationships among numbers, and number systems.	8	80%	
Math 2	Operations Sense: Understand the meaning of operations and how they relate to each other.	8	80%	
Math 3	Computation Strategies: Use of computational tools and strategies fluently and when appropriate, use estimation.	10	100%	
	Standards Rating		87%	
Measurement				
Math 4	Fluency with Measurement: Understand attributes, units, and systems of units in measurement; and use techniques, tools, and formulas for measuring.	6	60%	
	Standards Rating		60%	
Spatial Sense				
Math 6	Transformations and Symmetry: Use transformations and symmetry to analyze mathematical situations.	9	90%	
	Standards Rating		90%	
	Overall Rating		90%	

SOURCE: Apperson Datalink Software Reports.

Rubric-Graded Assessments

In order to reap the benefits of test data analysis you do not need to give a scannable multiple-choice test. It also is possible to score and receive item analyses for rubric-graded writing assignments, projects, labs, and speeches. Reports generated from analyses of rubrics provide all the diagnostic benefits for teachers and students discussed previously. Standards-based rubrics encourage teachers to communicate clear expectations for projects and provide students with clear goals for their work, while the performance criteria and scoring guides contained in well-crafted rubrics give students the opportunity to self-assess and improve their work along the way (Arter & McTighe, 2001).

The use of rubric-graded assessments can be viewed similarly to forced-choice tests as they, too, form a continuum of opportunities for teachers—from opportunities to make micro-adjustments to mid-lesson teaching to opportunities to make macro-adjustments to both curriculum and instruction.

Using Rubric-Graded Formative Assessment Data to Immediately Inform Teaching

When students at one Illinois high school were not performing well on the subtest of the scientific method on the state's Prairie State Achievement Test, the Science Department met to consider the state test results and consider how the scientific method was being taught and assessed at the classroom level. The teachers quickly determined that they thought they were teaching the scientific method when their students were involved in their regularly scheduled labs. They also realized, however, that though teachers felt the scientific method was being taught through the lab experience, students weren't really getting it. The state test revealed that their students couldn't really define a hypothesis or specifically distinguish the various parts of the scientific method.

The department's solution was to make the scientific method a learning target, teach the various parts of the method through direct instruction as well as through labs, and directly assess the scientific method on a variety of formative and summative assessments, including the common summative final exam.

Then, Megan Graham, one of the biology teachers, devised a formative assessment method that became known as "Clipboard Cruising" (see Figure 3.8). She created a rubric that evaluated her students' understanding of the terms that specifically defined the scientific method: formulate a hypothesis, use quantitative and representational methods to analyze measurements, draw conclusions from investigations, and so on. Then, armed with a rubric for each of her students on her clipboard, she moved from lab table to lab table and asked her students about the different components of the scientific method as they related to the lab her students were completing.

Figure 3.8 Clipboard Cruising

Lab or activity: _____

Standards/learning targets addressed: _____

Student name	Physically with team	Verbally with team	On task	Understands standards/ learning targets

Note: Created at DuPage High School District 88, Villa Park, IL. (2010) Reprinted with permission.

If the students understood the various components, they received a plus (+) on the rubric for each understood component. If they didn't understand, the "teachable moment" was created for Megan, and the student received immediate and relevant corrective feedback on the part of the scientific method he or she didn't understand. The rubric also recorded how well students worked with their lab partners and whether or not they were "on task." For group behaviors Megan put a + or –. She states, "My goal is to observe every team three times during a lab. It keeps the kids from hogging my time and makes them more aware of their behavior" (personal communication, May 2010).

Clipboard Cruising was a success in Megan's class, and soon all biology teachers were using the same mid-lesson formative assessment to assess learning and inform instruction as their students were completing their biology labs. A year later a similar process was successfully implemented for labs in physics and chemistry classes as well.

Using Rubric-Graded Formative Assessment Data to Inform Teaching Over Time

As teachers, we also are concerned about whether or not our students understand information, concepts, and processes that may be taught in multiple lessons. Certainly, a key process and life skill that is taught and assessed at all levels is writing, and use of rubrics is key in helping students to understand what is expected of them, how their writing will be judged, and how to improve their work along the way.

Vicky Edwards, a high school English department chair, writes,

Every fall, we introduce the State writing rubric to the students. All sophomores and juniors take a local writing assessment in class, and have it scored by those State standards. This year, teachers decided to use a general prompt (like the Prairie State exam will have) and to make it a quarter grade; the final exam prompt will be a literature-based question. Most teachers have the students do a practice (formative) writing using the rubric first, so they will get a feel for scoring. This rubric is used several more times first semester, which clarifies what the writing expectations are for the entire school. I also share this with the other department chairs, and have found that several teachers use them, thereby reinforcing the importance of writing in all content areas. This year, we began formal portfolios for all students, which will follow students through all four years, and will allow them to track common errors and make progress toward improving their writing. The local writing assessment and results will go in their portfolios, along with other class writings. (personal communication, July 2008)

In her statement, Vicky clearly outlines the process of helping students to write. Show them the rubric so that they understand what is expected of them, give them opportunities to practice and receive corrective feedback using the rubric, and then use the rubric as a scoring tool for summative writing assignments, for a quarter grade, as a final exam, and then on the high-stakes state test. In sharing the English department rubric with other departments, Vicky also is promoting better writing by trying to establish consistent expectations, performance criteria, and evaluation results among all teachers and departments.

The writing rubric Vicky describes (Figure 3.9) is an analytical trait rubric that divides the students' writing into essential traits so that traits can be judged separately. These traits are similar to the traits used by the state, and a separate score is provided for each trait, providing a profile of strengths and weaknesses in a piece of work. As with the forced-choice tests, the rubrics are scanned and analysis is completed for an individual student, a class, and/or an entire grade level. By looking at the rubric analysis, teachers as well as students understand the strengths and weaknesses of a piece of writing and are guided to next steps for improvement. As with other formative assessments, teachers use the information from analysis of rubrics to guide instruction.

Lisa Cuscaden, a teacher in Vicky's English department, writes,

> Realizing I really needed to differentiate [instruction] more, this year I tried something quite different. With the results I received from the local [formative] writing assessment, I had students complete exercises related to their weaknesses so that they truly understood where they were deficient. I also had them track their weaknesses on a tracking form for every essay from that point forward. This enabled them to focus on their own issues and not the generic ones I used to teach. I was pleased with how this process worked, but I look forward to next year even more, as (this year) I was learning with them. (personal communication, May 2008)

Rubric-Graded Benchmark Assessments

As with forced-choice tests, rubric-scored assessments also may be used as benchmark or summative assessments to track student progress over time, such as a grading period or a semester, and formatively to predict how students will perform on high-stakes state or college entrance tests. When using scoring rubrics, the teacher reads the written project or listens to the speech or performance, and then fills in the rubric, which has been aligned with the standards-based learning targets.

Figure 3.10 is an example of an "online" speech rubric, which is completed by a speech teacher using a laptop computer. As each student gives a speech, the teacher fills in the rubric. When the students are finished with their speeches, the rubrics are scored and the reports run. Both the online

Figure 3.9 Writing Rubric

DISTRICT 88 WRITING RUBRIC—November 2007

Euell, Lilia
7860423
DYNES, MATHEW
Eng 10–2 Basic Per5(A)

FOCUS—TOPIC DEVELOPMENT

4—Exceeds—Fully developed; effective sentences logically develop one main idea
3—Meets—Proficient skill in focus and in developing sentences of relevant support
2—Below—Basic understanding of topic development, with gaps in skills or logic
1—Academic Warning—Focus absent or unclear, little development or focus

ORGANIZATION—COHERENCE

4—Exceeds—Effective organization, cohesion, transitions, sentence fluency
3—Meets—Sufficient cohesion, appropriate support, proper intro, and conclusion
2—Below—Basic understanding of paragraphing and transitions, minor digressions
1—Academic Warning—Limited paragraphing, transitions, and structure

SUPPORT—WORD CHOICE—SENTENCE STRUCTURE

4—Exceeds—Depth of detail, enhanced word choice, varied sentence structure
3—Meets—Sufficient elaboration, word choice consistent with tone and purpose
2—Below—General support, limited detail, basic transitions
1—Academic Warning—Little elaboration or off-topic information

CONVENTIONS—USAGE—PUNCTUATION

4—Exceeds—Proper usage, spelling, punctuation, sentence structure, and capitalization
3—Meets—Knowledge of above conventions, but with less control than top papers
2—Below—General understanding, with errors in usage, spelling, punctuation, sentence structure
1—Academic Warning—Limited usage, spelling, punctuation, sentence structure

EXCEEDS =	A+	16 = 100%
	A	15 = 96%
	A–	14 = 92%
MEETS =	B+	13 = 88%
	B	12 = 84%
	C+	11 = 79%
	C	10 = 75%
	C+	9 = 71%
BELOW =	D+	8 = 68%
	D	7 = 64%

SOURCE: Created at DuPage High School District 88, Villa Park, IL. Reprinted with permission.

Figure 3.10 "Online" Speech Rubric

2002/2003 Speech Local Assessment

Mrs. Thomas INTRO SPEECH Period | 4

SMITH, ERIC 2040115

Topic	Exceeds	Gestures	Meets
Attention-Getting Opening	Exceeds	Articulation	Exceeds
Preview	Exceeds	Rate of Speaking	Exceeds
Supporting Details	Exceeds	Fluency	Exceeds
Transitions Used	Meets	Volume	Meets
Main Points	Exceeds	Enthusiasm	Meets
Sequence	Exceeds	Supplemental	Meets
Topic Summary	Exceeds	Organization	Exceeds
Clincher	Exceeds		
Facial	Exceeds		
Eye Contact	Does Not Meet		
Posture	Exceeds		

Total: | 172

0 = Does Not Meet
7 = Meets
10 = Exceeds

Wednesday, October 01, 2003

scoring of rubrics and the computerized analysis of the students' speeches greatly speed up the process of scoring, analyzing, and reporting student work. The quick turn-around time for the score reports gives teachers an immediate opportunity to judge students' progress toward standards-based learning targets and provide the necessary interventions.

Figure 3.11 shows how 470 students performed on the speech assessment. The criteria for the speech and the standards-based learning targets for the course are summarized in the left column. The number and percentage of students "not meeting," "meeting," and "exceeding" the criteria are listed to the right.

The results of the speech assessment indicate that the students need help in developing the body of their speeches with more supporting detail and in using more eye contact when presenting their speeches. While these weaknesses would not be a surprise to any of us who ever asked sophomores in high school to give a speech, the report does objectively identify two major weaknesses and would argue for an individual teacher, a teacher team, a department chair, or curriculum director to find resources to help remediate the weaknesses of these students.

The use of analyzed data from both formative and summative assessments provides us, as teachers, with a wealth of information to guide instruction, improve our curriculum, and help our students on their journey toward competence. If our assessments are clearly aligned to standards-based learning targets, which define what we want our students to know, then our formative test data clearly will tell us what our students do know and will give us the kind of feedback we need to help our students improve.

If used correctly, formative assessments provide us with information to help our students increase their learning and thus help them learn more and ultimately increase their achievement and scores on high-stakes summative assessments, such as graded unit tests, final exams, or state tests of standards, all of which sum up what a student has learned at a particular point in time.

It is helpful to view formative and summative assessments as complementary to one another. Formative assessments assess our local standards-based learning targets as they are being taught to our students and provide us with data to show what students have or have not learned as they are learning it. Summative assessments are used for a grade; document whether or not our students have exceeded, met, or fallen below whatever standards we have set or have had set for us; and show us how our students compare with others in their school, state, or country.

Using data from both formative and summative assessments is a vital source of power for teachers because together they provide a comprehensive picture of what our students actually know. If we use both types of assessments correctly, we can not only measure and report learning but also promote it.

Figure 3.11 Summary Report for Rubric-Graded Speech Assessment

After the district speech assessment was given to all sophomore speech students, the online scoring was summarized in the following report for 470 students:

Willowbrook High School 2002–2003 Speech Local Assessment

Topic	Does Not Meet		Meets		Exceeds	
Attention-Getting Opening	12	3%	37	8%	421	90%
Introduction—Preview	9	2%	167	36%	294	63%
Body—Supporting Detail	48	10%	193	41%	229	49%
Body—Transition	48	10%	193	41%	229	49%
Body—Main Points	16	3%	99	21%	355	75%
Body—Sequence	24	5%	217	46%	229	49%
Conclusion—Topic Summary	21	4%	229	49%	220	47%
Conclusion—Clincher	29	6%	322	69%	119	25%
Presentation—Facial	7	1%	236	50%	227	48%
Presentation—Eye Contact	42	9%	203	43%	225	48%
Presentation—Posture	10	2%	345	73%	115	24%
Presentation—Gestures	8	2%	372	79%	90	19%
Voice—Articulation	12	3%	292	62%	166	35%
Voice—Rate of Speaking	15	3%	138	29%	317	67%
Voice—Fluency	19	4%	350	74%	101	21%
Voice—Volume	9	2%	111	24%	350	74%
Voice—Emphasis/Enthusiasm	26	6%	240	51%	204	43%
Supplemental Materials	42	9%	167	36%	261	56%
Organization/Outline	28	6%	83	18%	359	76%
Overall	436	4%	4285	46%	4678	50%

SOURCE: Created at DuPage High School District 88, Villa Park, IL., 2003. From *Using Test Data for Student Achievement: Answers to No Child Left Behind* (p. 73), by N. W. Sindelar, 2006, Lanham, MD: Rowman and Littlefield. Copyright 2006 by Nancy W. Sindelar. Reprinted with permission.

Chapter Three Rubric: Making Data-Driven Decisions in the Classroom

	Not Yet	Sometimes	Always
I know how to gather and use data from my classroom assessments.			
1. I understand how to construct forced-choice and rubric-graded standards-based classroom assessments to determine discrepancies between what my students currently understand and what they need to know.			
2. I understand and use the high-stakes test data I receive from sources outside my classroom.			
3. I use data from formative and summative classroom assessments to identify areas for curricular revision, and areas for reteaching and individual student remediation.			
4. I have (my school has) a system in place to efficiently analyze assessment results and provide me with useful reports regarding my students' progress toward standards-based learning targets.			
I use data from forced-choice formative assessments to inform my instructional decisions.			
5. Immediately—while I am teaching.			
6. Over time—to make adjustments for reteaching and interventions before summative assessments.			
7. As predictors for results on high stakes tests			
I use data from rubric-graded formative assessments to inform my instructional decisions.			
8. Immediately—while I am teaching.			
9. Over time—to make adjustments for reteaching and selecting interventions before summative assessments.			
10. As predictors for results on high stakes tests			

(Continued)

(Continued)

Reflections

Ways this chapter has changed my thinking:

1.

2.

Next steps:

1.

2.

4

Empowering Students With the Results of Their Learning

Research on student learning has determined that feedback is "the most powerful single modification" that enhances student achievement and that the "simplest prescription for improving education is 'dollops of feedback'" (Hattie, 1992, p. 9). Yet, as teachers, we all have encountered students who don't listen to or seem to value our feedback. Though we spend hours grading and writing comments on our students' work, often they just look at the grade then crumple the paper and toss it in the wastebasket, hoping a friend will credit them with "two points."

Frankly, the difference between good students and weak students is that good students are able to absorb our feedback and use it to create a pathway toward understanding learning targets. Weak students, however, have trouble understanding feedback and need us to give them specific next steps in order for them to develop a growth mindset and see a path toward understanding. Unlike our good students, our weaker students often have given up trying to understand the comments written in the margins of their papers or don't know how to find solutions to the test items they missed. Because they don't understand how to improve, they often dismiss school and schoolwork as "stupid" or simply say, "I don't care."

Assessment-powered teachers understand the role of feedback and use formative and summative assessment results not only to inform their own teaching, but also to provide feedback to all their students that specifies next steps and creates pathways of learning for them. Assessment-powered teachers use frequent assessments coupled with corrective instruction to help their students identify next steps for improvement and make progress toward learning targets. This process is motivational to students, because it identifies errors in learning and is "followed by high-quality corrective instruction designed to help students remedy what ever learning errors [were] identified [by] the assessment" (Guskey, 2007, p. 21). Because the assessment and the corrective feedback are aligned to learning targets, students are better able to see a pathway to their own personal success and feel there's a reason to try. Because their teacher has provided them with next steps, they begin to think, "I can do this," and they are more motivated to take charge of their own learning.

The importance of frequent feedback was emphasized by the early research of the Behaviorist tradition. People such as J. B. Watson, Ivan Pavlov, and B. F. Skinner were major contributors to this line of thinking. They searched for universal laws of learning that could apply not only across individuals but across species. Their emphasis was on the role of positive and negative feedback in helping organisms learn to perform complex skills. Today, research in cognitive science shows that formative assessment and the feedback it provides to both teachers and students is extremely important to enhancing learning (Bransford et al., 2005).

When our classroom assessments are aligned with learning targets and standards and are an integral part of the instructional process, "the benefits of assessment for both teachers and students are boundless" (Guskey, 2007, p. 28). When students receive feedback that allows them to see their progress and shows them the steps to take to do better, they are motivated. Frequent feedback also makes them feel as if they are a "valued part of vibrant, 'high-standards' learning community—at the classroom level, school level, and overall community level—this is motivating as well" (Bransford et al., 2005, p. 75).

Assessment-powered teachers have seen success breed success by using assessment results to provide timely, "next steps" feedback to students and as a diagnostic tool for corrective instruction. These are some of the steps you can take to motivate and empower your students with the results of their learning.

Step One: Eliminate "Mystery Teaching" by Providing Students With Clear and Consistent Standards-Based Learning Targets and Assessments

Well-articulated learning targets work as instructional targets for assessment-powered teachers and learning targets for their students. When learning targets are clear, there is no mystery about what students are expected to know or the criteria by which their work will be judged.

Students receive learning targets (or the course curriculum in the case of high school students) at the beginning of a unit in age-appropriate language. These learning targets are reviewed and discussed with students, and posters with the student-friendly learning targets are placed on classroom walls and are referenced to and reinforced by teachers during the introduction of a unit and later during instruction. Because students know the focus for learning, they feel more engaged with the topic, bring their prior knowledge to the learning, and become more effective partners in the learning and assessment process.

Ann Davies (2007) cites two benefits that come from students understanding their learning targets or "destinations."

1. They begin to learn the language of assessment. This means students learn to talk about and reflect on their own work using the language of criteria and learning destinations. Later, this is the language they will use as they give themselves and others specific feedback to feed their learning forward.

2. They gain the knowledge they need to make decisions that help close the gap between where they are in their learning and where they need to be. (p. 38)

As instruction begins, assessment-powered teachers reference the learning targets, and their students understand that what they do in class is a means to reach a particular learning target or set of targets. Students are helped to understand what is expected of them by a clearly developed and defined shared vocabulary, by explanations of how their work will be judged, and by being shown performance criteria and scoring guides, such as the rubrics discussed in Chapter 3.

Assessment-powered teachers do not keep their learning targets and assessments a secret. Their students are not involved in tests that are guessing games or forced to answer "gotcha" questions. Rather, both formative

and summative assessments are aligned with the well-defined and articulated learning targets and the previously provided criteria on how the work will be judged (Guskey, 2007). An assessment-powered teacher would never say, "What's not covered in class will be covered on the test!"

Arter and McTighe (2001) cite the example of a middle school language arts teacher who emphasizes learning targets for new units by referencing a full-size archery target she obtained from the PE department and placed on her classroom bulletin board. In addition to talking about the learning targets for the new unit, she discusses the culminating performance and the rubric containing the criteria for the performance. Along with the learning targets and rubric, the bulletin board target also contains examples of student work collected from previous years. The work samples, which vary in quality, are connected to the different levels of the rubric, providing students with a clear illustration of the criteria and performance levels (p. 84).

This target is an example of an assessment-powered teacher in action. In addition to clearly identifying learning targets and criteria, the samples of student work are particularly helpful for students who struggle with feedback, because they act as a road map for producing quality work. It is important to match the sample selections to the learning needs of students so that students don't become frustrated because samples show work that is too advanced or fail to be inspired because the samples are too easy.

Identifying specific targets at the beginning of lessons motivates students to engage in learning because they are more likely to put forth the required effort when there is task clarity. Similarly, the practices we use to help our students understand the learning targets and how their progress toward them will be evaluated also enhance clarity and thus are motivational too.

Step Two: Give Students Specific Feedback Regarding Their Progress Toward Learning Targets in a Timely and Caring Manner and in a Format That Is Understandable to Them

Feedback on strengths and weaknesses needs to be timely in order for improvement to take place. When a student waits three weeks to find out how he did on a test, learning is not improved. When feedback is late, it seems irrelevant to our students, and we have lost the power to give corrective instruction to improve learning on current and subsequent lessons. Only timely, relevant feedback encourages students

to self-assess, improve their work, and make use of interventions. Timing is critical, and students must understand their "next steps" before they feel their fate, and their grade, is sealed by a summative assessment or before they just stop trying.

Of course, one of the huge benefits of embracing technology for scoring of tests and rubrics is the quick turnaround time and the ease with which assessments are scored. An additional benefit is that students' strengths and weaknesses are judged against specific learning targets and standards. The clickers described in Chapter 3 are motivational to students because of the speed and specificity with which students receive feedback.

Ryan Holy Eagle is using the clickers in his eighth-grade math class at St. Francis Indian School in South Dakota. After six weeks' use, Ryan's eighth-grade students increased their weekly quiz scores from an average of 20% to 90%. Ryan believes, "The technology gives students a way to instantly apply the concepts they learn." He also states, "They are too interested in learning to even think about acting up. It is like day and night" (Holy Eagle, n.d.).

Palm Springs Unified School District also is using clickers to enhance learning through visual cues and rapid feedback. Program evaluation conducted by California State University showed that students exhibited a high degree of student engagement (86–92%) and were more "motivated, engaged, focused, active, involved and excited" during lessons using the clickers (see www.einstruction.com for more information).

The immediate graphical display of students' classroom assessment results provided by the clickers also appears to enhance student learning. Fuchs and Fuchs's 1986 study found that displaying students' assessment results graphically was associated with a gain of 26 percentile points in student achievement (p. 200). Presumably, seeing an immediate graphic representation of students' scores provides teachers and students with more precise information from which to take the next instructional steps.

Feedback specificity is also key to helping students understand both their strengths and the areas in which they can improve. Giving students only grades and scores as feedback does not meet the specificity test. Merely assigning a grade, "B+," or writing a vague comment, "Nice Job," does not advance learning and can even be detrimental. My daughter was devastated when after spending weeks writing a high school research paper, her paper was returned on the last day of the semester with a "B+" and no other comment. She received absolutely no information on how to improve or where she had fallen short.

Specific comments in the form of corrective feedback help students learn. Guskey (2007) states,

> What better learning-to-learn skill is there than learning from one's mistakes? Mistakes should not mark the end of learning; rather, they can be the beginning. Some assessment experts argue, in fact, that students learn nothing from a successful performance. Instead, they learn when their performance is less than successful, for then they can gain direction about how to improve. (p. 24)

In *Leading in a Culture of Change,* Michael Fullan (2001) speaks to the importance of developing "assessment literacy through the examination of student performance data, the creation of capacity to examine student data and make sense of them . . ." (p. 14). A good way for us to develop the assessment literacy of our students is to personalize assessment analyses for each student and for each class. Through personalization, both formative and summative assessments truly become assessments for learning. Rather than signaling the need to move on to the next chapter, tests become an opportunity for both students and teachers to contemplate what has been learned, what has not been learned, and if additional study or reteaching is necessary.

Students become our partners in the assessment process when they are provided with the item analyses of their work. Individual data results of either forced-choice tests or rubric-graded projects provided by individualized item analysis reports allow students to target the concepts and problems that they need to relearn after initial instruction. In some cases the class report, as seen in Figure 3.7, may even reveal that an entire class is weak in understanding a particular problem or learning target.

Studies on classroom assessment show that simply telling students they are correct or incorrect in their answers has a negative effect on learning, whereas *explaining* the correct answer or asking students to *refine* their answer is associated with a gain in achievement of 20 percentile points (Bangert-Drowns, Kulik, Kulik, & Morgan, 1991, p. 227). Assessment-powered teachers organize relearning so this "explaining" and "refining" can take place in whole-group or small-group targeted instruction sessions or in student self-assessment interventional settings they have put in place.

Students in Joy Joyce's AP economics class frequently advanced to first place in the State of Illinois AP economics competitions because Joy provided her students with individual item analyses of

their unit tests. In class she would review and reteach the most frequently missed questions. By using item analysis for her entire class, as well as providing her students with the individual item analyses of their individual tests, she enhanced the quality of student learning, rather than merely evaluating it.

Joy states,

> Through a combination of teacher and student efforts, questions deemed MFMQ (most frequently missed questions) would be discussed, digested, and elaborated upon and, if necessary, additional practice would be assigned. Use of the data-driven teaching resulted in a consistently high level of success for students. (personal communication, July 2005)

Joy's students were successful because her assessments were followed by corrective instruction. When her students took their next assessments, they were able to demonstrate their new level of understanding. These follow-up assessments assessed not only students' understanding, but also the effectiveness of the corrective instruction they received.

The writing rubric and its use discussed in Chapter 3 is another example of how students can act on corrective feedback—first to learn or relearn and then to revise. As writers we all know that we rarely compose the perfect essay on the first try, which is why the research on the teaching of writing stresses writing as a process that includes prewriting, outlining, drafting, and editing all before the last stage of publishing.

Specific, descriptive feedback is helpful to students both before and after a written assessment or project. Rubrics help students become more analytical about self-assessment and more productive in seeing next steps because they provide students with specific criteria for success before they begin a project and show them where they have fallen short when the project is complete. When students compare their work to criteria on a rubric, they learn what elements of their work meet expectations and where they need to learn more to improve their work. Students understand this feedback more readily because it relates directly to their learning and enables them to demonstrate their learning in relation to a particular product. In their study on the effects of systemic formative assessment, Fuchs and Fuchs (1986) showed that student achievement is enhanced by 32 percentile points if assessment results are interpreted by a set of rules or criteria such as a rubric.

Providing students with specific and descriptive feedback helps students to be more focused on learning and make informed choices about what to do next. This motivates students because it contributes to their metacognitive awareness of the progress of their current levels of understanding and the gaps and areas needing development (Shepard, Hammerness, Darling-Hammond, Rust, Snowden, Gordon, et al., 2005).

Simply stated, it's important for us to help our students know what to do differently. When our feedback states: "Support this idea with details from the novel," rather than just saying, "Support?" we're providing a specific, grounded suggestion for improvement. This is more motivational to student learning than broader comments because it enables a student to engage in a thought process focused upon a particular action and enables the student to understand in concrete terms how to improve. When students have the opportunity and some guidance regarding what to do next, their engagement and achievement increase.

Step Three: Give Students Opportunities to Self-Assess and Improve Their Work

As teachers, we spend countless hours grading papers and writing comments in margins, only to have our students look at the grade and then toss the paper in the wastebasket. While we must analyze our students' work, we also need to develop opportunities for our students to think about their work and use our corrective feedback to develop next steps for meeting learning targets. When we teach our students how to use our feedback to analyze their work, it not only gives meaning to the time and effort we have put into grading and commenting on their work, but also engages our students in the learning process. Requiring students to think about and apply criteria for meeting learning targets in the context of their own work encourages students to monitor their own work and take responsibility for their own learning.

Getting students involved in analyzing their mistakes on tests helps them to understand the intended learning and to discover the immediate next steps they need to take in their journey toward learning targets. It also gives them a clearer picture as to just where they are in the journey. Hattie and Timperley's (2007) review of the research on feedback determined that analysis of mistakes is one of the most powerful ways students learn or increase their learning.

Assessment-powered teachers help their students learn by teaching them and giving them time to be more analytic about their own learning. Students learn to give meaningful and effective feedback to themselves and others by examining their work in relation to previously explained criteria and clarifying how they can improve their work.

We can begin to help our students identify their mistakes by providing them with item analyses of their tests or rubric-scored projects. Then we need to set up a system and give them time to consider why they made the mistake and what they will do differently next time. Figure 4.1 is an individual student proficiency report for a seventh-grade math test. With a little help in understanding the format of the report, Kelly will see that she needs to work on Computation Strategies, where she missed two of eight questions, and Spatial Sense, where she missed one of four questions. Kelly is a good student with an overall proficiency of 83%. Yet, giving Kelly this report will help her see areas for improvement and next steps. The report outlines the questions she missed and the chapters she needs to review. These are steps for making a good student even better. Giving Kelly this information and creating time and a structure for her to work on her next steps is far more powerful than simply assigning a "B" and moving on.

Figure 4.2, Thinking About Doing Better, is an example of a handout for helping students to analyze their mistakes on a forced-choice or short-answer test. Each student has a form and works in a group of two or three.

After students analyze their mistakes with a partner, they are asked to set some learning goals. When students examine what they are doing well and what they need to improve on, they are beginning the process of setting their own goals for learning. Students should be encouraged to set small, realistic goals, as the most useful goals are those that reflect steps along the way—not just the final outcome. Taking small steps helps students to self-monitor their way to success (Davies, 2007).

The use of rubrics is another important tool in helping students self-assess their work. When students are given a rubric in advance of the assignment, they have the opportunity to verify that they have met the specific criteria for an assignment. As teachers, we can help our students to self-assess by having them place checkmarks by each of the criteria listed on a rubric before our students give the assignment to us for evaluation. Ideally, the judgments of both the student and the teacher will match. If not, the discrepancy creates a teachable moment where you can discuss criteria, expectations, and

Figure 4.1 Individual Student Proficiency Report

Student Proficiency Report	Kelly Doherty	ID# 3008932

Instructor: Mechelle Pierce	Total Possible: 30	Student Score: 25 – 83%
Exam Name: Math 2nd Period	Highest Score: 30 – 100.00 %	Class Average: 25.7 – 85.67 %
Exam Date: Monday, July 25, 2005	Lowest Score: 22 – 73.33 %	Proficiency: >=75%

Standard	Description	Correct	Total	%	
Numbers and Operations					
Math 1	Number Sense: Understands numbers, ways of representing numbers, relationships among numbers, and number systems.	7	8	88%	
Math 2	Operations Sense: Understand the meaning of operations and how they relate to each other.	6	7	86%	
Math 3	Computation Strategies: Use of computational tools and strategies fluently and when appropriate, use estimation.	6	8	75%	
	Proficiency Level	19	23	83%	
Measurement					
Math 4	Fluency with Measurement: Understand attributes, units, and systems of units in measurement; and use techniques, tools, and formulas for measuring.	3	3	100%	
	Proficiency Level	3	3	100%	
Spatial Sense					
Math 6	Transformations and Symmetry: Use transformations and symmetry to analyze mathematical situations.	3	4	75%	
	Proficiency Level	3	4	75%	
	Overall Proficiency	**25**	**30**	**83%**	

Column header note: Responses (Correct, Total)

Missed Questions			
#	Correct	Your Answer	Prescriptive Information
9	B	C	Chapters 1-3 of textbook
12	D	E	Chapter 2, textbook
20	D	A	Chapter 7, textbook
27	E	C	
28	D	B	

SOURCE: Apperson Datalink Software Reports.

performance standards. Over time, our teacher judgments and those of our students will begin to align, though it is not unusual for our students to be harder on themselves than we are.

Ideally, a well-crafted rubric will include space for feedback comments and next steps. Consequently, the rubric moves from being simply an evaluation tool for assigning a final grade to a practical and student-friendly tool for self-assessment, corrective feedback, and goal setting.

Step Four: Provide Interventions to Help Students Reach Learning Targets in a Timely Manner

Ultimately, we want our students to self-assess, grow, and become independent learners. That said, we are still the teachers and need to monitor our students' growth toward targets and provide necessary interventions along the way.

The value of assessment is that it gives us that ongoing information to help our students reach specific learning targets. Most of us have files filled with lesson plans and activities. In addition to aligning these materials with the learning targets for initial lessons, it's important to use these resources for follow-up target lessons. We can harness the efficiency and effectiveness of assessment-powered teaching by not only organizing and aligning these materials to the initial learning targets, but also by varying the materials needed to reteach areas with which our students need more help. With just a little reorganization we can use our time-tested materials for short, targeted lessons purposely

Figure 4.2 Thinking About Doing Better

Directions: Identify three items (questions or problems) you missed on the test. Then, with a partner, decide why you missed the question and how you could fix it. Next, with your partner, write down what you will do differently the next time you encounter a similar question or problem. Budget your time to eight minutes per item.

Item number	Why I got it wrong	How I can fix it	What I will do next time

My Goals

Directions: By yourself write down two learning goals and the activities you will engage in to reach them. If you need help identifying activities, ask your partner or your teacher.

Goal One:	Activities for Goal One:
Goal Two:	Activities for Goal Two:

directed to help students in the specific areas in which they are strug-gling. Formative assessments create the power of the teachable moment. We need to seize that moment and use our time-tested mate-rials for target lessons that will help our students move down the pathway toward success.

A high school English teacher, Lisa Cusaden, came to the realiza-tion that she could be more effective by targeting specific grammar and writing errors she saw in her students' writing. After using the English department's rubric, she created her own Writing Skills Checklist (Figure 4.3) to deal with the various interventions needed by her students.

The value of Lisa's checklist is the clarity and ease with which it provides "next steps" for her students. English teachers often use the symbols that Lisa has listed and assume their students know what they mean when, of course, they don't.

Lisa stepped up to addressing the clarity issue by explaining, simply and in writing, what the symbols mean. Then she provided the next step of telling her students where in their grammar book the grammar rule was explained. She then dealt with the specificity issue by marking only the grammar rule that was relevant to the particular student.

Those of us who have taught English know the "rules" have been explained to our students over and over. We know, too, that our students perceive grammar as boring and often tune us out. Lisa's checklist creates a teachable moment because it's clear, relevant, and timely to her students. It definitely provides next steps, even to the student who tuned out of grammar years before, because it provides an easy, user-friendly pathway to success and motivates them to learn just what they need to know to improve.

The bottom line is that assessment-powered teachers help their students believe in their potential for success because they clearly define what their students need to know and provide the criteria their students need to successfully learn and meet their learning targets. They have built assessment systems that provide valuable informa-tion to pinpoint gaps in learning and show their students the next steps they need to take to eliminate the gaps. Because their students are involved in the assessment process and know how to self-assess, they have a sense of ownership and commitment to learning. They now are focused, motivated, and achievement oriented.

Figure 4.3 Writing Skills Checklist

WRITING SKILLS - Upperclassmen Name _____

Writing Assignment

Writing Skill/Rule _I can use correct grammar, spelling, punctuation, and structure._	_Hacker_ Page #, Rule	Teacher Mark										
HYPHENS Use a hyphen to connect two or more words that function as an adj., and other hyphen rules	301-02 M2-a, b, c, d, e	⊖ or ‾∧										
CAPITALIZATION Capitalize proper nouns, titles, major words of titles, quoted sentences, etc.	303-07 M3-a, b, c, d, e, f, g	≡										
ABBREVIATION/NUMBERS Use standard abbreviations properly; spelling out numbers, addresses, etc.	307-311 M4 and M5	(error circled)										
ITALICS/UNDERLINING Underline titles of works; quote titles of articles, short stories, poems, etc.	311-12 M6; 284 P6-d	NO UNDERL‾ ∿∿∿										
SENTENCE ERRORS Fragments, run-ons, errors in structure, awkward wording	101-05 S3-c,d, e; 109 S5-a	frag, r-o, s.s., awk										
PARALLELISM Balance parallel ideas in a series and in pairs. /Marked lines go around part that should be parallel/	93-96 S1-a, b,c	//										
VERB TENSES Tense consistency; use all present tense when describing literary plot	105-108 S4-a,b, c; 180 G-2	vt										

Writing Skill/Rule *I can use correct grammar, spelling, punctuation, and structure.*	Hacker Page #, Rule	Teacher Mark										
SENTENCE VARIETY Coordinate equal ideas and subordinate minor ideas; combine choppy sentences	112-119, S6-a, b, c, d, e, f; S7-a, b, c	*var*										
SPELLING Make error on back, or check dictionary, or check usage in Hacker "Glossary of Usage" 124-137	123-137, W1	(*error circled*) OR *sp*										
WORD CHOICE Eliminate wordy structure; use active verb; avoid jargon/slang/colloquials; formality; wrong word	137-156 W2,3,4,5	*w* *colloq* *w w*										
AGREEMENT Subject/verb; indefinite pronouns; collective nouns; pronouns/reference	163-198 G1-G3-a, b, c, d	*agr*										
QUOTATIONS Direct quotes, quote-within-quote, punctuation with quotes	282–87, P6-a, b, c, d, e, f, g	∧ *add* *omit* *lead-in*										
COMMAS With clauses, introductory phrases, quotes, dates, etc.; unnecessary commas	259-273 P1-a–j, P2-a–g	∧ or ⋀ (*add comma*) ⸺ (OMIT)										
OTHER PUNCTUATION MARKS Semicolon, colon, apostrophe, period, ?, !, dash, parentheses, brackets, ellipsis, slash	273-282 P3, P4, P5 288-293, P7-a-h	*p*										

SOURCE: Lisa Cuscaden (personal communication, May 2007).

Chapter Four Rubric: Empowering Students
With the Results of Their Learning

	Not Yet	Sometimes	Always
Step One: I've eliminated "mystery teaching" by providing my students with clear and consistent standards-based learning targets and assessments.			
1. My students are exposed to standards and learning targets at the beginning of instruction.			
2. My students know how their work will be assessed when instruction begins.			
3. I provide my students with examples of student work that meet the criteria for successful understanding of the learning targets.			
Step Two: My students receive specific feedback regarding their progress toward learning targets in a timely and caring manner and in a format that is understandable to them.			
4. My students receive specific target-based corrective feedback to give them "next steps" toward improvement.			
5. My students have a structure and class time to begin their next steps toward improvement			
Step Three: Students are given opportunities to self-assess and improve their work.			
6. My students have opportunities for self and peer assessment.			
7. I have developed rubrics and worksheets that guide my students in the self-assessment process.			
Step Four: My students receive timely interventions that help them reach learning targets.			
8. My students understand where they are in relation to learning targets and the steps they need to take in order to reach them.			
9. I provide my students small group and individual interventions directed at specific learning targets.			
10. I have developed target lessons and special materials to use for interventions.			

Reflections

Ways this chapter has changed my thinking:

1.

2.

Next steps:

1.

2.

5

Powering Achievement in Culturally Diverse Classrooms

A s teachers, we encounter the different experiences and academic needs of a broad range of students on a daily basis. Our classes are filled with students with a wide range of abilities, who come from different ethnic backgrounds and speak a variety of languages. As a profession, we have embraced diversity and the richness it brings to our classrooms as well as the daily challenges of implementing practices to maximize the achievement of all of our students.

The diversity within our classrooms is increasing, and the achievement gaps among subgroups are becoming a professional, political, and moral issue. In 1972, students of color constituted 22% of the school population; by 2003 this proportion was more than 41% (National Center for Education Statistics, 2007a). By 2035 demographers project that students of color will constitute a majority of the student population in the United States (Hodgkinson, 2001).

The number of children in schools who are English language learners also is increasing. There were 1.5 million English language learners in 1985; in 1995 there were nearly 3.2 million. In the United States in 2000 over 50 million people (18% of the population) spoke a language other than English at home, and that number grew to over 54 million in 2007 (U.S. Census Bureau, 2009). No two English language learners have the same amount of knowledge or competency

in their primary language or are in the identical stage of English-language acquisition (Almeida, 2007).

Diversity in the range of academic abilities within classrooms is also growing as schools include more students with exceptional needs in mainstream classrooms. In 1998, 8.6% of six- to twenty-one-year-old students participated in special education. In 2004, 9.2% of six- to twenty-one-year-old students participated in special education and nearly half of them (47%) spent 80% or more of their time in general education settings (National Center for Education Statistics, 2002).

Not only are our classrooms becoming more diverse, but No Child Left Behind legislation now requires that progress be charted for subgroups identified by race and ethnicity, free and reduced lunch, special education, and English language learners. As David Figlio (in Beck, 2008) of Northwestern's School of Education and Social Policy comments, "One thing that is attractive about accountability and No Child Left Behind is that [it] shines[s] a light on the performance of every child" (p. 7).

Thus, as we plan our instruction and develop and analyze our assessments, we need to take into account the cultural perspectives and the differences in progress for our lower-achieving and higher-achieving subgroups as well as any apparent performance differences for genders. Though the NCLB legislation requires the charting of progress for various subgroups, merely charting progress is not enough. Our professional judgment must be brought to bear to explain the cause of differences in performance, and constructive feedback and follow-up instruction need to occur to maximize the performance of all subgroups and all students.

Assessment-powered teachers embrace the "Demographic Imperative" by taking action to alter the disparities in opportunities and outcomes deeply embedded in the American education system that have contributed to the gaps in achievement among student groups who differ from one another racially, culturally, and socioeconomically (Banks, Cocharna-Smith, Moll, Richert, Zeichner, LePage et al., 2005, p. 236). They take seriously the education of all children and continue to make progress in reducing the inequality in student achievement by examining ways to bridge the gap between what their students know and what they need to learn. They believe in success for all students and take action on this ideal. They don't just pride themselves on a 90% pass rate, but rather identify the 10% who are failing, examine the reasons for their failure, and use assessment data to power continuous improvement for all of their students.

Though the achievement levels of Hispanic students as documented by the National Assessment of Educational Progress (NAEP) mathematics and reading assessments are consistently and markedly lower than levels for white students (National Center for Education Statistics, 2007b), English language learners have become star pupils in the Washington D.C. area, thanks to inspired teaching, and their teachers are drawing accolades as top-performing schools that serve immigrant communities show standout results on state reading tests and national rankings. The latest National Assessment of Education Progress ranked Virginia's English language learners first in the nation for fourth-grade reading and Maryland's fifth in the nation (deVise, 2009, p. A01). Shelley Wong (2009), president of Teachers of English to Speakers of Other Languages, credits this success to the caliber of professionals "who are constantly thinking about how to make connections between communities, families and schools" (p. A01).

As teachers we all have felt the pride and exhilaration that comes from helping our students excel. We know and believe that to teach is to touch a life forever, and as teachers in a changing world, we know the importance of refining our skills to meet the demands of our increasingly diverse classrooms. Though the steps discussed in the preceding chapters apply to all students, the following steps outline some of the successful practices you can implement to help diverse learners reach learning targets and maximize their academic potential.

Step One: Become a "Cultural Broker"

Assessment-powered teachers are aware of the cultural and the linguistic patterns that exist within their own culture, their teaching, and their assessment practices. They work to develop an awareness of the multiple cultural perspectives that exist within their classrooms and nurture a broadened perspective that allows them to create opportunities for all their students to learn and articulate their views. They are not only concerned with what their students need to know, but also with designing a learning environment that maximizes their students' opportunities to learn. As Geneva Gay (1993) argues, "a teacher needs to be prepared to be a 'cultural broker' who thoroughly understands different cultural systems, is able to interpret cultural symbols from one frame of reference to another, can mediate cultural incompatibilities, and know how to build bridges or establish linkages across cultures that facilitate the instruction process" (p. 293).

While most would agree that becoming a "cultural broker" is a good idea, acting on this ideal may be difficult. Where do we begin to

understand a culture different from our own? How do we go about the process correctly? How do we get around inaction or institution-alized beliefs that it's normal for some groups to perform lower aca-demically than others?

We begin by viewing what goes on in our classrooms with an equity lens. We look for that 10% who are failing and ask ourselves why. In our team meetings and in conversations with colleagues, we search for ideas and strategies that enable similar subgroups to achieve better results. We examine our own cultural assumptions to understand how they influence our teaching and then begin to ask the uncomfortable questions that deal with race and ethnicity in order to gain understanding of our students' cultural practices and build a more culturally responsive set of teaching strategies.

We learn that to foster the strengths of diversity and create equity within our classrooms, we must adjust our teaching strategies and communication patterns to draw out and include all of our students in discussion and interactions. The more diverse our classes are, the more different perspectives there will be in a discussion, thereby increasing the chances of generating creative ideas and finding sub-stantive solutions to problems. Once our equity lens is in focus, we are comfortable drawing out various cultural perspectives, and our skills as "cultural brokers" develop.

Reducing the communication gaps among the cultures of students and between students and the teachers is an important skill used by culturally responsive teachers. Third-grade teacher Demetrius Sajous-Brady uses "interpretive discussion" with his students and finds that it improves his students' ability to analyze what they read, ask questions, provide evidence for their reasoning, and draw out ideas from classmates (Stein, 2009, p. 9). Using this method, his students decide on a text-based question they'd like to discuss and answer from their different cultural perspectives. As a result, students are more engaged, better able to appreciate the perspectives of their classmates, and develop a shared understanding of the material and the learning target.

As awareness of multiple cultural perspectives increases, cultur-ally responsive teachers also create opportunities for students to express how popular culture shapes their views. As teachers we already know the importance of making connections between our students' prior knowledge and experiences and our learning tar-gets. As diversity increases, we can further refine this skill through the use of "cultural modeling," a successful method for connecting our students' out of school knowledge to academics in order to increase their learning.

In working with African-centered schools in Chicago, Carol Lee uses rap music to teach African American teenagers about literary symbolism. This is her way of employing "cultural modeling" to use what students know from an everyday setting to support specific subject matter learning (Stein, 2009, p. 6). Carol finds that incorporating cultural knowledge into literary interpretation produces longer and more sophisticated comments about the text.

Additional bridges also can be built by providing extra clarity in explaining learning targets, by using various modes of communication during instruction, by being sensitive to assessment needs, and by providing specific feedback. Delpet (1995) makes the point that especially for students whose home culture is different from that of the school, demystifying school expectations and learning strategies is critical. When providing direction, culturally responsive teachers use multiple modes of communication so that students who process information differently are able to understand them. They also facilitate the learning of their diverse learners by varying their instructional strategies. Use of videos, computer programs, field trips, and visual aids to support active learning have all been found to be highly successful.

Assessment-powered teachers are sensitive to providing levels of accommodation and support to help their diverse learners reach learning targets. In general, accommodations are changes to the manner in which an assessment is given that would ordinarily be held constant. Shaw (2005) makes the point that accommodations are "rational responses to student diversity without ascribing a deficit value to certain characteristics, such as level of proficiency in English" (p. 349). Thus, assessment-powered teachers are open to providing the flexible time needed for student learning by individualizing timelines for project completion or by allowing more time for test taking. They also vary the level of support or the amount of assistance to learners by having students work in groups with peers or adult mentors.

Las Palmitas Elementary School in Thermal, California, is using adult volunteer mentors to help groups with varying abilities meet learning targets. As Xochiti Pena explains, "Many of the children's parents are migratory farm workers, most of whom don't speak enough English to help them with their studies" (p. 1). In this program students are divided into groups, and English-speaking volunteer mentors individualize feedback and corrective instruction on topics identified by missed test questions. A similar "Read with Me" program was instituted at Mecca Elementary School, in Mecca, California, and after one year the school was recognized for making the largest gain on the state test of any school in the county (Pena, 2009, p. 1).

This type of mentoring is strongly supported by the research of Elawar and Corno (1985), who found that effectiveness of feedback can be dramatically improved when mentors focus on assessment results and ask three questions: "What is the key error? What is the probable reason the student made this error? How can I guide the student to avoid the error in the future?" (p. 165). As mentioned previously, feedback is most productive when it focuses on specific criteria for meeting learning targets, identifies strengths and weaknesses in student work, and provides guidance about what to do next.

Becoming a "cultural broker" requires looking at teaching through an equity lens and building a practice that not only focuses on learning targets, but also is highly responsive to a broad range of student needs. By being aware of our own cultural perspectives and increasing our awareness of the cultural perspectives and needs of our students, we too can become "cultural brokers." In doing so, the differences among our students will be tapped as an advantage, and our students with a multitude of backgrounds and needs will be assimilated into a high-achieving classroom community.

Step Two: Analyze the Needs of Subgroups Through the Use of Disaggregated Test Data

The preceding chapters have shown how teachers gain tremendous power from using analyzed data from both formative and summative assessments. Knowing where our students are in their journey toward learning targets makes our teaching efforts both effective and efficient because our teaching is focused on the specific needs of our students.

However, when test data represent all groups within a class or school, overall averages can hide learning problems that do not reveal themselves until the data are disaggregated in order to describe each subgroup that was tested. A teacher can take pride in the fact that 85% of a class of fourth graders are meeting or exceeding learning targets in reading, but that percentage may hide evidence that a specific subgroup has reading comprehension below the 40th percentile. Unless we examine disaggregated data on a regular basis, the needs of subgroups of students within our classes may be overlooked.

Traditionally, teachers receive disaggregated data for subgroups when the reports from the yearly state high-stakes tests required by NCLB are sent to schools. This information is helpful in making large-scale adjustments, such as those described in Chapter 3, and in providing rankings for subgroups that compare achievement levels with

other students in the school, the state, and the nation. Yet, to be responsive to our student subgroups, we need more frequent subgroup test data in order to track progress toward learning targets and provide specific feedback and next steps. Receiving a yearly snapshot of achievement for students who are no longer even in our classrooms is just not enough. We need to monitor the progress of our subgroups by using disaggregated data from our own formative assessments.

Fortunately, software programs make it possible to separate test results by subgroup, and assessment-powered teachers are running test reports for specific groups of students, grouped by gender, race, ethnicity, curriculum type, or income level, by simply coding their students' answer sheets. By disaggregating the data from their formative classroom assessments, these teachers are able to examine how various subgroups in their classrooms are progressing toward learning targets and standards and identify subgroups that may be experiencing difficulty with a particular learning target or a particular set of test questions.

Without disaggregation, the subgroup experiencing difficulty is usually hidden in the overall average score of the larger group. Without disaggregation of data, it's easy for us to move on, thinking that all of our students "get it," not knowing that a small percentage of students don't get it and need specific feedback that will help them reach learning targets and allow us to close the "achievement gap." Thus, to achieve equity in our classrooms and to help all subgroups reach learning targets and standards, we need to disaggregate the data from our formative and summative assessments to determine how our students in different subgroups are progressing toward learning targets and standards.

A study focusing on state test scores of Chicago Public School students revealed that 85.3% came from low-income families, 50.8% were African American, 36.1% were Latino, 9.6% were White/Non-Latino, 3.3% were Asian-American and 14.3% were limited English proficient, and that students from low-income families, African American families, and Latino families did less well than other students on the state tests (Commercial Club of Chicago, 2003, p. 6).

The 2002 state test scores showed that only 30% of the African American students met or exceeded standards in reading, and 16% met or exceeded standards in math; that 35% of Latino students met or exceeded standards in reading, and 26% in math; 60% white/non-Latino met or exceeded in reading and 55% in math; and 57% Asian American students met or exceeded standards in reading and 62% in math (Commercial Club of Chicago, 2003, p. 65).

The same study went on to say that there was no credible evidence to support the notion that children from poor families or from particular ethnic groups were, on average, less capable of learning than others and that "good teaching" and "effective schools" were the "most important factors in student learning" (Commercial Club of Chicago, 2003, p. 2). The study stated that "data-driven decision making and strong internal accountability systems [were] core characteristics of high-performing schools and [were] all but unknown in poorly performing ones" (Commercial Club of Chicago, 2003, p. 52).

The study supported the notion that both formative and summative assessments were critical to increasing achievement, stating that "teachers need better information about how students are doing while they are learning, as well as after the fact" (Commercial Club of Chicago, 2003, p. 52).

This recommendation is especially critical since all of our students, regardless of race, ethnicity, or economic status, are expected to meet or exceed state standards by 2014. By analyzing the disaggregated data of our formative assessments, we are not only able to increase the achievement levels of all students, but also can help students in different subgroups remediate their weaknesses before they take the high-stakes summative state assessment required by NCLB.

Clearly, disaggregating the data from formative and summative assessments is a power tool that further increases our ability to focus on the needs of all of our students. Because our classes are becoming increasingly diverse, we greatly benefit from analyzing the progress of various subgroups. Given the right kind of data analysis software, this is not a time-consuming task.

Figure 5.1 is an example of a comparison report that disaggregates test data for a high school U.S. history course-end summative assessment. This report shows how each subgroup performed on each of the U.S. history learning targets tested on the course end exam.

One of the learning targets and state standards for the course was for students to interpret documents. When looking at the results, we can see that black/non-Hispanic students did not perform as well as other students on this part of the test. Only 61% met the learning target of interpreting documents. Though this subgroup did not stand out as being low performing on other learning targets tested on this assessment, they clearly did have problems interpreting documents.

It's interesting to note that Figure 5.2, which analyzes the results of all the students tested, shows 89% of all the students taking the test as meeting or exceeding the learning target of interpreting documents.

Figure 5.1 Disaggregation of Student Test Data for U.S. History

Standard Group Comparison	US HIST SURVEY SEM 1 FINALSS32071:95/0 FCC/P ITEMS

11/14/2007

Group	Designation			Total Mastery
DOCUMENTS: Interpreting Documents				
ASIAN / PACIFIC ISLANDER [06–07]	(93%) 14 of 15 have Mastered this Departmental Goals. 0% Expected.			
	Exceeds		7	47%
	Meets		7	47%
	Does Not Meet		1	7%
BLACK/NON-HISPANIC [06–07]	(61%) 11 of 18 have Mastered this Departmental Goals. 0% Expected.			
	Exceeds		4	22%
	Meets		7	39%
	Does Not Meet		7	39%
HISPANIC [06–07]	(84%) 21 of 25 have Mastered this Departmental Goals. 0% Expected.			
	Exceeds		10	40%
	Meets		11	44%
	Does Not Meet		4	16%
WHITE NON-HISPANIC [06–07]	(92%) 184 of 200 have Mastered this Departmental Goals. 0% Expected.			
	Exceeds		118	59%
	Meets		66	33%
	Does Not Meet		16	8%
MULTIRACIAL [06–07]	(80%) 4 of 5 have Mastered this Departmental Goals. 0% Expected.			
	Exceeds		3	60%
	Meets		1	20%
	Does Not Meet		1	20%
LOW INCOME [06–07]	(78%) 7 of 9 have Mastered this Departmental Goals. 0% Expected.			
	Exceeds		5	56%
	Meets		2	22%
	Does Not Meet		2	22%

SOURCE: Created using the Assessor by Progress Education at DuPage High School District 88, Villa Park, IL. Reprinted with permission.

Figure 5.2	Nondisaggregated Student Test Data for U.S. History

Standard Mastery Report

11/14/2007 2006–2007 School Year	**U.S HISTORY**

	Forced Choice Mastery		**Performance Mastery**		**Total Mastery**	
Compare/Contrast						
→ EXCEEDS	77	29% (8 of 10) 80%	0	0% (0 of 0) 80%	77	29%
→ MEETS	114	43% (6 of 10) 60%	0	0% (0 of 0) 60%	114	43%
→ DOES NOT MEET	77	28% (<6)	0	0% (<0)	77	28%
☺ COMPARE/CONTRAST—(72%) 191 of 265 have Mastered this learning target						
Interpreting Documents						
→ EXCEEDS	144	54% (13 of 16) 80%	0	0% (0 of 0) 80%	144	54%
→ MEETS	92	35% (10 of 16) 60%	0	0% (0 of 0) 60%	92	35%
→ DOES NOT MEET	29	11% (<10)	0	0% (<0)	29	11%
☺ DOCUMENTS—(89%) 236 of 265 have Mastered this learning target						
Draw Conclusions						
→ EXCEEDS	102	38% (10 of 12) 80%	0	0% (0 of 0) 80%	102	38%
→ MEETS	83	31% (7 of 12) 60%	0	0% (0 of 0) 60%	83	31%
→ DOES NOT MEET	80	30% (<7v)	0	0% (<0)	80	30%
☺ DRAW CONCLUSION—(70%) 185 of 265 have Mastered this learning target						
Weigh and Evaluate Evidence						
→ EXCEEDS	102	38% (9 of 11) 80%	0	0% (0 of 0) 80%	102	38%
→ MEETS	103	39% (7 of 11) 60%	0	0% (0 of 0) 60%	103	39%
→ DOES NOT MEET	60	23% (<7)	0	0% (<0)	60	23%
☺ EVALUATE—(77%) 205 of 265 have Mastered this learning target						

(Continued)

Figure 5.2 (Continued)

	Forced Choice Mastery		Performance Mastery		Total Mastery	
Point of View						
→ EXCEEDS	239	90% (1 of 1) 80%	0	0% (0 of 0) 80%	239	90%
→ MEETS	0	0% (1 of 1) 60%	0	0% (0 of 0) 60%	0	0%
→ DOES NOT MEET	26	10% (<1)	0	0% (<0)	26	10%
☺ POINT OF VIEW—(90%) 239 of 265 have Mastered this learning target						
Growth of Colonies/American Revolution						
→ EXCEEDS	141	53% (16 of 20) 80%	0	0% (0 of 0) 80%	141	53%
→ MEETS	104	39% (12 of 20) 60%	0	0% (0 of 0) 60%	104	39%
→ DOES NOT MEET	20	8% (<12)	0	0% (<0)	20	8%
☺ SS32071-A—(92%) 245 of 265 have Mastered this learning target						
Civil War & Reconstruction						
→ EXCEEDS	128	48% (12 of 15) 80%	0	0% (0 of 0) 80%	128	48%
→ MEETS	102	38% (9 of 15) 60%	0	0% (0 of 0) 60%	102	38%
→ DOES NOT MEET	35	13% (<9)	0	0% (<0)	35	13%
☺ SS32071-B—(87%) 230 of 265 have Mastered this learning target						
Great Plains/Native American						
→ EXCEEDS	70	26% (6 of 7) 80%	0	0% (0 of 0) 80%	70	26%
→ MEETS	83	31% (4 of 7) 60%	0	0% (0 of 0) 60%	83	31%
→ DOES NOT MEET	112	42% (<)	0	0% (<0)	112	42%
☹ SS32071-C—(58%) 153 of 265 have Mastered this learning target						
Industrialization/Immigration						
→ EXCEEDS	115	43% (17 of 21) 80%	0	0% (0 of 0) 80%	115	43%
→ MEETS	101	38% (13 of 21) 60%	0	0% (0 of 0) 60%	101	38%
→ DOES NOT MEET	49	18% (<13)	0	0% (<0)	49	18%
☺ SS32071-D—(82%) 216 of 265 have Mastered this learning target						

SOURCE: Created using the Assessor by Progress Education at DuPage High School District 88, Villa Park, IL. Reprinted with permission.

Basically, the low performance of the black/non-Hispanic subgroup is hidden unless the test data are disaggregated. The difference in the information on student achievement of subgroups that the teacher gains from Figure 5.1 and 5.2 shows the value of disaggregating test data. By doing so, we can uncover learning problems that otherwise could be hidden from us.

The information gained from studying Figure 5.1 argues for a target lesson with this subgroup that focuses on the close and careful reading of documents and specific strategies to determine what these documents are saying to the reader. This group of students does not "get" how to interpret documents and would benefit from a target lesson focused on methods of historical inquiry, ways to interpret historical inferences, and strategies to identify different types of evidence found in historical documents.

When we take the time to disaggregate data and look at the results, we can easily identify topics for target lessons and next steps for low-achieving subgroups. In doing so, we can quickly and efficiently increase the achievement of all students and bring greater equity to the education our students are receiving in our classrooms.

Step Three: Address the Needs of Subgroups by More Accurately Measuring What Students Know Rather Than Their Ability to Communicate Their Knowledge in Standard English

Assessment-powered teachers use multiple modes of assessment as an ongoing part of instruction to ensure that their students have an equal opportunity to demonstrate what they know. Teacher questioning is an assessment mode all of us use to assess what our students know about a topic before instruction begins, whether or not our students are with us as the lesson progresses, and what our students have learned from the instruction that has taken place. One of the challenges we face, however, is how to effectively assess our diverse learners' knowledge rather than their ability to communicate their knowledge with fluency in Standard English.

Cultural practices equip students differently. Some Native Americans are reluctant to participate in class discussions or answer questions because their parents rarely engage them in questioning at home (National Research Council, 2001).

It is all too easy to conclude that some cultural groups are deficient in academic competence, when the differences can instead be attributable to cultural variation in the ways students interpret the meaning, information demands and activity of taking tests. (p. 32)

When we engage our students in class discussions and question them, we need to take into account our own experiences and speech patterns so that children who come to our classrooms with very different experiences and speech patterns are able to understand us as well as demonstrate their knowledge rather than appear deficient because they are unfamiliar with our speech patterns or modes of questioning.

To increase our own sensitivity to students' language patterns, we can become familiar with community speech patterns and incorporate elements of communication patterns, such as "call and response," even while we instruct in Standard English (Banks et al., 2005, p. 245). For students of varying language backgrounds, we can also allow the use of multiple languages while teaching in the target language. By being more sensitive to and flexible about the speech patterns of our students, we are able to more accurately measure what our students know or have learned rather than just their ability to communicate that knowledge in Standard English.

In addition to becoming familiar with their students' speech patterns for verbal assessments, successful teachers of diverse learners often use performance-based assessments because they yield more accurate results with English language learners than traditional assessments. Because of vocabulary and value-laden questions, some traditional assessment tools may greatly underestimate the knowledge a student possesses. The results of performance assessments tend to be more indicative of students' actual understanding of a concept or skill, while forced-choice, short constructed-response tests may provide less valid data, because they rely on students' understanding of standard English at a certain level (Almeida, 2007).

Performance assessments, such as rubric-graded projects, labs, speeches, and performances, all do a better job of assessing content knowledge rather than content knowledge *and* the ability to communicate it in Standard English. When these assessments include tools or artifacts that are used in a student's everyday life, the assessment's ability to capture a student's understanding of a concept or a problem is also increased (Edd Taylor, in Beck, 2009).

Because performance assessments are graded by rubrics, we are better able to communicate the essential features of good work to our

students, and our students have a clearer understanding of the criteria by which their work will be judged. Also, modern assessment software makes the grading of rubrics efficient and accurate and also gives us the ability to disaggregate test data by subgroup.

Figure 5.3 is an example of a rubric for assessing students' ability to speak a language other than English. Students are asked questions in the target language and then formulate a response in the target language. They are assessed on the quality of their response, the quality of their expression and use of vocabulary, their use of grammar, the quality of their pronunciation, and their use of verb tense and mood. As the students are responding to questions, the teacher either directly marks the rubric and scores it on a scanner or inputs the evaluation onto a laptop computer (see Figure 5.4). In either case, the tests are scored and the reports printed. A similar rubric and scoring system could be created for almost any subject, project, or performance.

Figure 5.5 is a report that disaggregates the data for various language classes and various subgroups within the classes. It's interesting, but not a surprise, that the highest score for pronunciation in Spanish I was the Hispanic subgroup. Using students from this subgroup to lead student triads in pronunciation would be good use of this information. Not only would the non-Hispanic students profit from learning better pronunciation, but also there's the added benefit of giving the Hispanic students, who may be low achievers in other classes, leadership roles as the class experts in pronunciation. (It should be noted that students who were native Spanish speakers were taking Native Spanish I or II.)

The point here is that rubric-scored performances and projects can be scored efficiently and that disaggregated data can easily be obtained from such assessments. Assessment-powered teachers gain power from the use of performance assessments because they create a more successful environment for English language learners and appeal more to students who may be struggling with speaking and writing in Standard English. Assessment-powered teachers know that assessment, like instruction, is ineffective if it is unresponsive to differences in children's experiences and cultural knowledge.

As our classrooms become more diverse, we need to consider that each of our students has a special cultural perspective, an individual learning style, and individual language needs. Some of our students will learn better visually; some will be more amenable to auditory input. Some students will do their best learning using words and sentences, though they may use different words and sentence patterns than what we are used to hearing in our classrooms.

Figure 5.3 Rubric for World Languages

Willowbrook Department of World Languages
Evaluation of Oral Performance—January, 2007 Sem 1

ID#

NICKELS, TAMMY
German 2
Period: P6(A)
Wolff, Justin—2091146

TOPIC: _____

QUALITY OF RESPONSE

- A/5 = Meaningful, appropriate, and thoughtful response
- B/4 = Above-average response
- C/3 = Appropriate response
- D/2 = Weak to poor—suggests incompetence
- E/0 = Irrelevant or incomprehensible

QUALITY OF EXPRESSION/VOCABULARY

- A/5 = Ease of expression, considerable fluency and vocabulary
- B/4 = Some awkwardness of expression
- C/3 = Strained expression, halting, may self-correct
- D/2 = Unfinished answer due to lack of resources
- E/0 = Clearly demonstrates lack of preparation

QUALITY OF SYNTAX/GRAMMAR

- A/5 = Virtually free of significant errors in syntax/grammar
- B/4 = Few errors in syntax/grammar
- C/3 = Some serious errors in syntax/grammar
- D/2 = Little control of syntax/grammar; fragmented target language
- E/0 = Clearly demonstrates lack of preparation and study of class concepts

QUALITY OF PRONUNCIATION

- A/5 = Virtually free of pronunciation errors and is appropriate to language level
- B/4 = Few errors in pronunciation, especially in more difficult constructions
- C/3 = Some serious errors in pronunciation
- D/2 = Pronunciation interferes with communication
- E/0 = Clearly demonstrates lack of preparation and lack of attentiveness in class

QUALITY OF VERB USAGE—TENSE/MOOD

- A/5 = Precise usage; may have minimal errors in more complex constructions
- B/4 = Good usage; virtually free of errors in basic constructions
- C/3 = Appropriate usage; some errors in basic constructions
- D/2 = Little control of appropriate verb usage
- E/0 = Clearly demonstrates lack of preparation and required drill and practice

Point Values A = 5, B = 4, C = 3, D = 2, E = 0
Conversion: 25 – 23 = A, 22 – 20 = B, 19 – 17 = C, 16 – 14 = D, 13 – 0 = F
EXCEEDS = 25 – 20 pts.
MEETS = 19 – 15 pts.
DOES NOT MEET = 14 – 0 pts.

Comments _____

SOURCE: Created at DuPage High School District 88, Villa Park, IL. Reprinted with permission.

Figure 5.4 Computer Screen for Rubric for World Languages

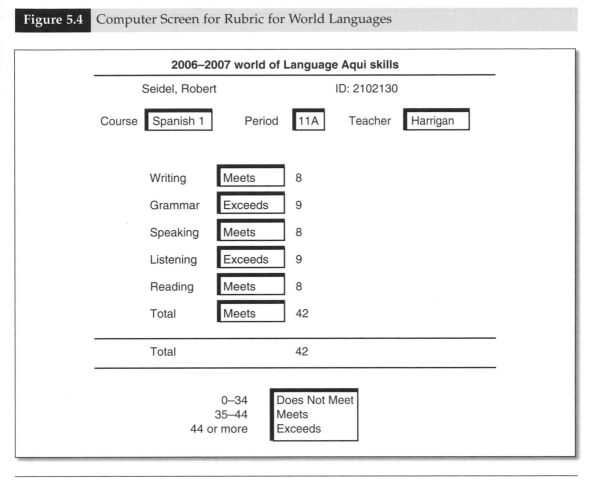

SOURCE: Created at DuPage High School District 88, Villa Park, IL. Reprinted with permission.

By developing our sensitivity as "cultural brokers" and by taking the time to look at the results of disaggregated student test data, we can learn the special needs of our diverse learners. This information will empower us to deliver more focused target lessons to subgroups, help all students to see important "next steps," and close the achievement gap by truly implementing equitable practices within our classrooms. We will empower our teaching and our students' learning by creating classrooms in which our students get what they need to make the greatest possible academic progress and become equal members in our high-achieving classroom community.

Figure 5.5 Disaggregated Student Test Data for World Languages

Willowbrook Department of World Languages Evaluation of Oral Performance—January, 2006—Semester 1 (Ethnic)							
	Count	Response	Vocab	Syntax	Pronunciation	Verb	Total
Summary for AP French							
Asian/Pacific Islander	1	5.00	5.00	5.00	5.00	5.00	25.00
White Non-Hispanic	3	4.33	4.33	4.33	4.67	4.67	22.33
Summary for French 3 Honors							
Hispanic	2	5.00	5.00	5.00	5.00	5.00	25.00
White Non-Hispanic	3	4.00	4.33	4.33	4.33	4.33	21.33
	5	4.40	4.60	4.60	4.60	4.60	22.80
Summary for French 4 Honors							
Asian/Pacific Islander	2	5.00	5.00	5.00	5.00	5.00	25.00
Black Non-Hispanic	1	4.00	4.00	4.00	4.00	3.00	19.00
White Non-Hispanic	17	4.56	4.38	4.38	4.13	4.31	21.56
	20	4.56	4.39	4.22	4.17	4.28	21.61
Summary for German 3 Honors							
Asian/Pacific Islander	2	4.00	4.00	4.00	4.00	5.00	21.00
White Non-Hispanic	58	4.21	4.17	3.62	4.76	4.34	21.10
	60	4.20	4.17	3.63	4.73	4.37	21.10

	Count	Response	Vocab	Syntax	Pronunciation	Verb	Total
Summary for Native Spanish 1							
Hispanic	8	4.25	4.13	4.13	4.00	4.13	20.63
Multi-Racial	1	5.00	5.00	4.00	4.00	4.00	22.00
	9	4.33	4.22	4.11	4.00	4.11	20.78
Summary for Native Spanish 2							
Hispanic	6	5.00	5.00	4.67	4.83	5.00	24.50
	6	5.00	5.00	4.67	4.83	5.00	24.50
Summary for Native Spanish 3							
Hispanic	7	5.00	5.00	5.00	5.00	5.00	25.00
White Non-Hispanic	1	5.00	5.00	5.00	5.00	5.00	25.00
	8	5.00	5.00	5.00	5.00	5.00	25.00
Summary for Spanish 1							
Asian/Pacific Islander	9	4.11	4.56	4.44	4.89	4.44	22.44
Black Non-Hispanic	15	3.33	3.60	3.60	4.13	3.67	18.33
Hispanic	11	4.18	4.64	4.18	5.00	4.45	22.45
Multiracial	4	4.75	5.00	5.00	4.75	5.00	24.50
White Non-Hispanic	120	4.21	4.34	4.30	4.72	4.29	21.86
	159	4.13	4.32	4.25	4.69	4.27	21.67

(Continued)

Figure 5.5 (Continued)

	Count	Response	Vocab	Syntax	Pronunciation	Verb	Total
Summary for Spanish 2							
Asian/Pacific Islander	20	4.50	4.40	4.35	4.35	4.25	21.85
Black Non-Hispanic	15	3.47	3.40	3.47	3.20	3.20	16.73
Hispanic	11	3.91	4.09	4.09	4.64	3.82	20.55
Multiracial	3	3.67	4.00	3.00	4.33	3.33	18.33
White Non-Hispanic	175	4.21	4.07	4.02	4.18	3.97	20.44
	224	4.16	4.06	4.00	4.15	3.92	20.29

SOURCE: Created at DuPage High School District 88, Villa Park, IL. Reprinted with permission.

Chapter Five Rubric: Powering Achievement in Culturally Diverse Classrooms

	Not Yet	Sometimes	Always
Step One: I am a "cultural broker."			
1. I am aware of my own cultural perspectives as well as those of my students.			
2. I am aware of my own verbal idiosyncrasies and the modes of questioning I use in my classroom.			
3. I understand the speech patterns of my students and am flexible about the sentence structure and vocabulary students use in my classroom.			
Step Two: I disaggregate test data to monitor the progress of subgroups toward learning targets.			
4. I use disaggregated test data to understand the strengths and weaknesses of subgroups within my classroom and to provide corrective feedback to subgroups.			
5. I provide target lessons to subgroups in need of additional instruction and help these students to identify next steps for reaching learning targets.			
Step Three: I address the needs of subgroups in my classes by assessing what students know rather than their ability to communicate their knowledge in standard English.			
6. I am aware of cultural differences in language patterns that impact students' verbal responses to questions and involvement in class discussions.			
7. I use performance-based assessments to allow my diverse learners to demonstrate what they know to the fullest extent and to measure students' progress toward learning targets.			
8. I disaggregate test data from rubric-graded performance assessments to understand the strengths and weaknesses of subgroups within my classroom and provide corrective feedback and "next steps" to subgroups.			

(Continued)

(Continued)

Reflections

Ways this chapter has changed my thinking:

1.

2.

Next steps:

1.

2.

6

Harnessing the Power of Collective Wisdom

Formative assessments are assessments for learning. Who learns? Our students learn, but so do we. We learn about what our students know and what they don't know, and we have the information we need to define next steps for their learning. We also learn about our own teaching and which of our materials and methods work and which don't.

Our new knowledge gives us the power to transform our classrooms, motivate our students, and help all of our students reach learning targets and higher levels of learning. Our new knowledge also lets us know that some of our methods and materials are not so effective, that there are gaps in our own knowledge that need to be remedied, and that there are systems issues within our school or district that need to be changed in order for us to be as efficient and effective as possible.

While much of the power we gain from data analysis of formative and summative assessments is harnessed and released within our own classrooms, we can gain additional power when the experiences and information we gain from our work within our own classrooms are shared with our colleagues in regular team meetings. Meeting in teams benefits us as individual teachers because the experiences, information, and data from each team member contribute to the collective wisdom of the team. When teams commit to using this collective wisdom to shape their ideas into new classroom practice, and

then measure and reflect on the results of this new practice, professional growth and student achievement skyrocket. Clearly, being part of a grade-level or subject-area team helps us as individual teachers reach our ultimate goals of informing and changing our classroom practices in specific ways that benefit our own students.

Teamwork is challenging and sometimes a little threatening. Sharing the data that document your students' progress toward learning targets can be stressful, and some team members will resist analyzing data and want to rely on "what I know works" even if they don't have proof. Yet, the power and influence of a team's collective wisdom cannot be overlooked. Teams often have the power to bring about changes that could not have been accomplished by an individual teacher alone.

Team-powered changes that lead to improvement fall into three basic categories: data-driven changes in curriculum and instruction, data-driven staff development initiatives, and data-driven student interventions. While these categories focus on different types of efforts, they all begin with teams looking at data, identifying areas of strength and weakness, and determining means for building upon the strengths and remedies for reducing or eliminating weaknesses.

Working in a team also empowers us as individual teachers to influence the operation of school systems that often are cumbersome and slow moving. Rather than feeling like a victim, asked to meet standards imposed by others and the incredibly diverse needs of learners, working in a team gives us the strength and the collective power to achieve our goals. Team proposals that are clearly explained and accompanied by credible data are powerful arguments for changes and improvements within a school. Negative outcomes, combined with a team's proposal for improvement, can inspire commitment to systemic change. Positive outcomes often reward those who have worked to turn things around and inspire broader support for change.

Data-Driven Changes in Curriculum and Instruction

The change process falls into a continuum. At one end are large-scale changes that have an effect on many students. At the other end are small-scale changes or methods of individual help that will only affect a few students at a time. Most of the changes identified in a team meeting will be large-scale changes that impact our grade level, our subject area, or the system itself. However, as team members we can also gain insights into changes that we can make as individuals

to improve the learning in our classrooms or identify new ways we can help just one or two of our students.

Changing the curriculum by using materials that are more closely aligned with standards-based learning targets is a large-scale change that is an effective means for improving the achievement of many students. In 2004, Chicago's Little Village Elementary School's math scores on the Illinois Standards Achievement Test (ISAT) jumped from 43% to 92% meeting standards in third grade and from 34% to 68% meeting standards in fifth grade. The school attributes this increase in achievement to the adoption of a new math curriculum that emphasized higher-order thinking and hands-on training for teachers (Dell'Angela, 2004).

Taking a closer look at vertical curriculum alignment is another effective means for improving achievement. When elementary teachers in South Routt School District in Oak Creek, Colorado, met to review their grade-level expectations for student writing, they decided to establish specific exit outcomes for each grade level. For example, when students left first grade they would be able to write "complete sentences with spaces, capitals, and punctuation." When they left second grade, they would have been "introduced to five-sentence paragraphs" and know how to use a "plan to write a paragraph." When they left third grade they would be able to write simple and complex sentences and "understand the structure of a paragraph and apply organization to their writing." In these team meetings, teachers also discussed materials to be used and new methods for scoring student writing. When students took the state writing test in fourth grade, higher scores were reported. In 2008, 24% of the students scored as proficient or advanced; in 2009, 50% of the students scored as proficient or advanced.

In addition to changing and refining curriculum, teams find new ways to improve learning by examining timing and pacing issues within the curriculum. Students frequently do poorly on a test because a subject or topic has not been adequately covered in the curriculum prior to their taking a high-stakes test. It may be that the topic simply is not included in the curriculum, not studied in depth, or not sufficiently covered in the textbook or with supplementary materials; or it may be that the topic is covered in the curriculum after the students take the local benchmark assessment or state test. We can remedy any of these problems by adjusting the curriculum and adding new instructional materials and formative assessments to address the topic before our students take high-stakes summative assessments.

When team meetings focus on pacing, the team will learn that one teacher may go into great depth on many of the learning targets and

standards, but have trouble covering all the material by the end of the year. Another teacher may move through the curriculum more rapidly, but in less depth. As the discussion ensues, both teachers will be looking for ways their pacing can increase student achievement. The "in depth" teacher may decide she just spends too much time on a particular learning target or a standard, while the "rapid" teacher may decide that his students would perform better in all areas if he went into greater depth on each of the key learning targets and standards. Usually, these kinds of team discussions result in both teachers changing the pacing of their instruction, changes the team encourages because they will lead to increased student achievement in both teachers' classes.

Teams also are able to identify systems issues, such as course requirements, that are impacting student achievement of key learning targets and standards. It's possible for us to have done a great job in aligning our local curriculum and assessments with learning targets and state standards but not have our school's graduation requirements ensure that all students have exposure to these key learning targets and standards. For example, most states have math standards that require knowledge of algebra and geometry. Yet in many high schools students can fulfill the math graduation requirement by taking pre-algebra and algebra, causing large percentages of students to have no exposure to geometry whatsoever. Because the state tests require knowledge of algebra and geometry, schools in this situation need to revamp their graduation requirements as well as the math curriculum so that all students have some exposure to algebra *and* geometry. This is not a teaching issue, a curriculum issue, an assessment issue, or an instructional issue. It's a systems issue.

Though schools in this situation often consider adding geometry as a third required year of math, adding more yearly requirements isn't necessarily a good solution because often there isn't enough time in students' schedules to add requirements. Rather, it may be more practical for teams to examine course sequences and vertical alignment to make certain that standards are met by existing requirements prior to students taking high-stakes tests. As mentioned in previous examples, student learning and test results improve dramatically once students have exposure to the standards.

Data-Driven Staff Development Initiatives

When we examine the results of our teaching individually or in a team setting, we not only see the strengths and weaknesses of our

students' learning, we see the strengths and weaknesses of our own teaching. Initially, this scenario is personally intimidating, but we soon learn that we are not alone. Our team members also have strengths and weaknesses.

Good teams share their wealth. Members exchange successful ideas and practices and build upon each others' strengths. As individual teachers, we see ways in which we can improve. If the atmosphere is collegial, we are encouraged to share our lessons, methods, and assessments with our team members, who have become our critical friends. Together we examine our students' test results against a set of learning targets and standards and give each other feedback in an effort to make our teaching more effective.

One of the most meaningful methods of staff development is for a team of teachers to review the item analysis of a recent common assessment and discuss areas of strength and weakness in students' progress toward specific learning targets or standards. Teachers report that when they review data in team meetings, their instruction becomes more focused on learning targets and standards and more goal-oriented toward helping all students meet or exceed standards.

Jeanne Gatherum, a fifth-grade teacher in Southern California, reports,

> In our math team meetings we spend at least two meetings a month analyzing data from the common district exams. We use results compiled by our district analysis system that are broken down by standard and disaggregated by gender, cultural background, language proficiency, and special educational needs. We compare our individual results to the district's and each other's. Initially we dialogue within our department to discover and share how the teachers of students performing well on certain standards helped them to excel. A good example of this occurred during the 2007–2008 school year. After the first common assessment, the students of one particular teacher scored higher than all of us . . . on the mastery of adding and subtracting integers and positive and negative numbers. As we discussed this in our team, the teacher shared with us that as he introduced the concept he used a number line, as we all did, but he oriented the line vertically while we all used the horizontal line format found in the majority of texts and supplemental materials. When we all retaught the concept incorporating the vertical number line, our scores showed improvement on the concept review portion of the following district assessment. (personal communication, November 2008)

Conversations such as the one that occurred in Jeanne's team are an important form of staff development that promote continuous improvement in teaching and student learning. Jeanne learned from her team because the information was based on data, was relevant to her own teaching, and because she was willing to listen and was open to trying a new way of doing things in her classroom.

In addition to learning from the individual methods of our team members, teams work well to identify broader-based initiatives for staff development. Our students' test data may reveal to us that the team needs additional training in a particular subject or learning target. For many years colleges and universities were sending English majors off to teach "English" with very little training in how to teach writing. I know. I was one of them. As a literature major, I took few writing courses and no methods courses in how to teach writing. During my first years of teaching, I assigned literature-based writing assignments and graded them, but I didn't know how to really help my students improve their writing.

It wasn't until research had been completed on the writing process that teachers in my situation were taught how people actually learn to write, and we could break down a writing assignment into teachable segments, such as pre-writing, outlining, drafting, and revising, and help our students to understand and use the writing process. A summer workshop in the writing process gave me confidence and enthusiasm for teaching writing.

Because of the workshop, I knew how to teach writing and could really identify next steps to help my students improve. My teaching was revitalized, and I shared my new knowledge with teachers in my own department and in schools where I gave writing workshops. This new information made a difference in our lives as teachers and in our students' writing.

In our rapidly changing world, team discussions can also identify recommendations for staff development workshops in target curriculum areas where we need to learn totally new subject matter. When DNA and cell physiology was introduced into the biology curriculum at a Chicago-area high school and some of the biology teachers had not studied DNA in college, the biology team quickly requested DNA workshops and retooled so that they could teach their students the intricacies of a DNA helix.

In addition to team discussions signaling a need for additional staff development to help us deliver segments of our curriculum more effectively, questions about assessment often surface in team meetings. Because effective team meetings focus on the results of assessment-based, data-driven instruction, it is critical that we have

easy access to analyzed assessment reports and understand what they are telling us.

The analyzed results of our formative assessments inform us as individuals as well as members of a team about the progress of our students. These assessment results should be the driving force for our curriculum, our instruction, our staff development, and the interventions we initiate for our students. However, if these results are not analyzed and used by us for daily planning, then our formative assessments are not really assessments for learning. Without analysis, we don't learn from assessments.

If we are going to use formative assessments and implement data-driven instruction, we need to have and understand the analyzed results of our formative and summative assessments. This means we need useable, understandable reports that give us quick feedback regarding our students' progress so we can give meaningful and timely feedback to our own students and reteach as necessary.

Given the amount of technology that is available to schools, it does not make sense for us to hand score and analyze assessments. Many of the sample reports in this book are examples of data collection and analysis that were generated in a school "Assessment Center." The Assessment Center contained a computer, a scanner, and the appropriate software for completing item analyses of both forced-choice tests and item analyses of assessments that were rubric graded. A trained, clerical staff member, who scanned and scored tests and generated reports requested by a teacher, a teacher team, a department chair, or an administrator, staffed the Assessment Center. Subject-area teams within the school were trained to understand the reporting capability of the system and given the analysis skills needed to benefit from the reports.

During the time of local assessments, such as high school common final exams, we brought our students' answer sheets or the teacher-completed rubrics to the Assessment Center for scoring. Scanned and scored tests were returned to us within twenty-four hours, complete with a numeric score and a letter grade. Reports were generated after all of our students took a particular local assessment and were returned to teachers and administrators in a timely manner so we could review and discuss the results and initiate changes in the curriculum and/or instruction as soon as possible.

Despite the technological revolution that has taken place in this country, schools have been slow to embrace the benefits of technology. There still are schools that don't have scanners or systems in place to efficiently score and analyze student work, and teacher education programs are just beginning to address how teachers can make

use of assessment information. As Richard Stiggins (2002) has said, U.S. educators remain "a national faculty unschooled in the principles of sound assessment" (p. 765).

Schools around the country, however, are now building assessment centers, identifying data coaches, and training teachers in staff development efforts to support data-driven instruction and promote higher levels of learning for all students. Teachers at all grade levels are finding that automated assessment analysis and detailed reporting of student performance by standard "allows for better remediation on an individual [student] level . . . and for identification of subject areas requiring additional coverage at the class level" (Kipp Rillos, personal communication, April 2010).

After district benchmark testing at Desert Sands Unified School District in Southern California, test results are immediately available to teacher teams. Teachers there report,

> We are able to see specifically which standards are mastered and which ones need reteaching. We are also provided with a list of common mistakes students made in choosing certain wrong answers. As a math team we review and discuss the data and use it to drive our future lessons. (J. Gatherum, personal communication, November 2008)

"Systems" support and staff development are invaluable to the use of formative assessments and the implementation of data-driven instruction. As we work to raise standards and the achievement of our students, schools also need to raise standards for the "system" so that teachers and students are informed by timely and relevant data about the learning that is taking place in their classrooms. Though students, teachers, administrators, parents, and community members all want information about student achievement, genuine accountability rests not only with test scores, but on a comprehensive system of support for teachers as they engage in data-driven instruction. Easy access to understandable, analyzed test data is a key component in this system and helps us improve instruction, student learning, and accountability.

Data-Driven Student Interventions

While large-scale changes in student achievement can occur by changing a textbook, small-scale changes occur by the various methods we use to help our individual students reach learning targets.

Item analyses of formative assessments identify our students' gaps in understanding and provide us with ample information to help them take the next steps needed to attain learning targets.

The challenge is for schools to have a system in place to help individual students take the "next steps" and not have the help for individual students fall solely on the shoulders of the students' teachers. Teams are good at defining intervention needs and finding ways for building a system of help for individual students. Though most schools have some interventions in place, data-based team proposals for additional interventions can fill in significant gaps in a "pyramid of interventions" and be major forces for gaining commitment from administrators, teachers, and support staff in implementing interventions that help students reach learning targets and standards.

There are basically three steps teams can follow in promoting and establishing "systems" interventions for helping individual students.

1. Use test data to identify students' individual strengths and weaknesses

The referral to any program to help students should be based upon student data that provide accurate information about a student's strengths and weaknesses and, when necessary, the causes of the student's learning problems. Data from our formative assessments will provide this information, and such data will help determine whether the student needs one or two sessions with a tutor on the causes of the Civil War or needs to be enrolled in a semester of developmental reading.

After we initiate a referral, it needs to progress to the individual within the school who has the power and capacity to place the student in the appropriate "help" program in a timely manner. In most schools, this person is a guidance counselor. Unless there is a designated contact, the intervention may falter in providing appropriate and timely help to a student.

2. Develop a sequential system for helping students take next steps to reach learning targets

Using data, teams can develop specific student interventions that progress from voluntary and unstructured to being required and structured. To increase achievement on an individual basis, initially students may need only a few extra minutes of individual help in our classrooms. Certainly, person-to-person contact and a positive

student-teacher relationship is an ideal and economical way to increase achievement. Unfortunately, this type of help may place an unrealistic burden on us, as individual teachers, as we may have too many students to help on an individual basis.

In large high schools, where many teachers have 150 students or more, an instructional resource center is a good solution to helping students on an individual basis. In an instructional resource center, students can meet one on one with teachers and tutors to receive individual help. This type of resource is an example of a help program that is at the unstructured and optional end of the continuum, in that students voluntarily go to the "IRC" to receive help during their study hall or before or after school.

The continuum becomes more structured and less voluntary when students are assigned to the "IRC" on contract for a semester. This means that students have to report five times a week for help until their classroom teacher and counselor decide the weaknesses are remediated and extra help is no longer needed.

A number of schools also have student writing labs, where a student may receive help from a teacher assigned to the writing lab or student tutor on a writing assignment. Another option is a "guided study hall," where the study hall teacher has been advised by the classroom teacher of a student's missing assignments and makes certain the student completes the assignments in a timely manner.

If students' weaknesses do not respond to less structured, voluntary help measures, then more highly structured programs need to provide help. Frequently, students who do not respond to the voluntary, less-structured forms of help have a more long-term deficiency, such as poor reading skills. In this situation, students may need special summer programs or an additional reading class that will improve their reading skills. A number of schools examine students' entry-level reading and math scores and recommend or require summer school programs for students who are below grade-level performance in these areas.

Finally, poor academic performance may also be triggered by family or emotional problems, substance abuse, or other problems that may require attendance in a support group or intensive counseling.

3. Monitor student progress

Once students' weaknesses have been identified through our own formative assessments, the intervention process should begin as soon as possible. First, we use our classroom strategies for target lessons

and individual help, and then, if necessary, we move to the "systems" interventions that are in place outside our classrooms. The key to helping an individual student improve is a wide and well-publicized continuum of help, a continuum that begins with the "next steps" kind of classroom help described in Chapter 4 and progresses to a "systems" program that is first optional and less structured and then progresses to a "systems" program that is mandatory and more tightly structured. Once a student is receiving extra help, we can monitor her progress though our own formative assessments to determine if the weaknesses are being remediated or if another form of help is needed.

Effective teams are well aware of the levels of help for students and how the continuum of help is accessed. When effective teams see need for an intervention they cannot provide in their own classrooms and that isn't being provided by the system, they use their collective power to write a data-based proposal and make it happen.

Making the Most of Team Time

The power of a team to make changes to a school system is impressive. Many schools are recognizing the value of teamwork and professional learning communities and incorporating team time into teachers' schedules. Combined with data analysis, it is the most powerful method of staff development for increasing student achievement. The following are suggestions from successful teams for making the most of team time:

1. Organize your team according to grade level and/or subject area

In a grade-school setting all fifth-grade teachers would be given common time to meet to discuss their common curriculum and the results of fifth-grade common assessments. In a high school setting teams would be organized according to courses taught. All algebra teachers would be on one team; geometry teachers would be on another. In a large high school setting one teacher is likely to be on more than one team because they are likely to have more than one teaching prep. In a small high school, a team might be composed of the entire math department, because there are not multiple teachers teaching a particular course. Rather, one teacher teaches all the sections of algebra, and another teaches all the sections of geometry. Depending on the size of the school, teams fall into different, but logical patterns of

membership. It's important, however, that the structure and member-ship pattern of a team match the team's purpose.

2. Find time to meet on a regular basis

Teachers are busy people with packed schedules. Finding a time for team meetings is often an initial barrier. Though there is no prede-termined formula for how often a team should meet, successful teams build regular structures and make team meetings a high priority. Actual meeting time depends on the structure of the school's schedule and calendar and the state of the curriculum and assessments when teams are formed. Elementary schools frequently are able to schedule weekly team meetings. High schools are often able to hold afterschool team meetings on a monthly basis. The number or frequency of meet-ings is not as critical as the fact we need to have enough time, at least one hour, to review data and develop next steps and action plans.

3. Begin by focusing on data

The analyzed results of a standards-based formative or summa-tive assessment at any grade level for any subject will generate team discussion on the need for curriculum revision, changes in instruc-tion, changes in teaching materials, changes to the assessment, staff development needs, student interventions, and more. However, team meetings must begin with data. Without data, discussions lose focus and often degenerate into complaining.

4. Have a simple agenda

Because meeting time is precious, it is important to have an agenda to focus the discussion as well as to alert teachers to the mate-rials they should bring to the team meeting. While individual teams may comfortably progress from meeting to meeting with a general knowledge of what the agenda will be, agendas greatly increase pro-ductivity for vertical team meetings, where fifth-, sixth-, and seventh-grade teams meet to discuss the sequence of fifth-, sixth-, and seventh-grade standards in science, or cross-departmental team meetings, such as when U.S. history teams meet with American liter-ature teams to discuss how and when the standards regarding post–World War I American culture are being addressed by each subject.

The challenge of teamwork lies in the interplay of people, tasks, and processes. High-performing teams tap into the unique talents of

individual members, value diversity of opinion and the act of bringing creativity to process. Yet team members need to work together, be clear about a common purpose, and have commitment to goals. Having a simple agenda helps to identify tasks and goals and enables teams to be more productive and effective.

5. End every team meeting with a defined action plan that will stimulate an improvement in student achievement

Effective teams do much more than merely look at the data. They improve learning by identifying actions they can take collectively and individually to improve teaching and learning. An important part of every team meeting is an action plan that documents students' learning needs and stimulates improvement in student achievement. Some teams simply address this change or action under the heading of curriculum or assessment revision. Other teams write goals. Others write goals and action plans. The format is not critical, but building a team culture of using data to foster continuous improvement in teaching and learning is.

Your team can develop its own format for defining action plans that lead to improvement in learning, use an existing school format, or use or adapt one of the following examples. Figures 6.1 and 6.2 are sample formats successful teams have used to document assessment results and action plans.

When we take time to reflect on our students' test data, it's easy for us to improve our curriculum and find new instructional methods to help our students learn. By using data to monitor the effectiveness of our own teaching and by updating our repertoire of teaching strategies by "sharing the wealth" in team meetings and participating in targeted professional development opportunities, our effectiveness in the classroom improves and our students begin to achieve at a higher level. Continuous improvement becomes a state of mind, and we begin to feel its power.

But, becoming an assessment-powered teacher does require some change. Whether you're considering these ideas from the perspective of an individual teacher, a team member, or a school leader, you may be feeling slightly overwhelmed at the prospect of becoming a data-driven educator. Don't be overwhelmed. Change comes in increments, and there are individual teachers, teams, and whole schools around the country that have met the challenge.

Figure 6.1 Team Meeting Data Analysis Protocol Form

Data Analysis Protocol Form

DATE	DEPARTMENT	GRADE/CONTENT	EXAM : _____

Participants:

Successes:	Challenges:

Focus:

Instructional Strategies:	We Agree On:

Smart Goal:	Results Indicators:
The average % correct on Standard ____ will increase from ___% to ___% as measured by _____ given on ___.	

Agenda topic for next meeting: (Topic, Purpose, Time. . . . Fill out next Departmental Meeting Report Sheet)

What to bring to next meeting:

SOURCE: Created at Desert Sands Unified School District, LaQuinta, CA. Reprinted with permission.

Figure 6.2 Team Learning Log

Team Learning Log: From Problems to Solutions

Assessment:

Standard/Learning Target:

Area of Weakness:

Instructional Solution:

Results or Measurable Impact of Solution:

Carmi-White County High School was on the State of Illinois academic watch list when they embarked on a program to improve. They formed teams, aligned their curriculum and assessments to state standards, developed interventions, and became the "Most Improved" School in the state in 2004. With hard work and clear focus on data and student achievement, they built a school culture that uses student test data to improve student learning (see Figure 6.3).

At the awards ceremony for Carmi-White and the other "Academic Improvement Award" winners, State Superintendent Robert Schiller reported the key factors in school improvement that were reported in the survey of the award-winning principals. The factors mentioned by the principals included the following:

1. Nearly every principal cited strenuous efforts to align curriculum across grades with the Illinois Learning Standards.

Figure 6.3 Most Improved High Schools, 2004

Most Improved Illinois Schools, May 2004
Most Improved High Schools

School	2001	2002	2003	Gain
CARMI-WHITE COUNTY HIGH SCHOOL	36	42.2	55.2	19.2
CERRO GORDO HIGH SCHOOL	47.4	54.2	65.2	17.8
MT OLIVE HIGH SCHOOL	46.8	56.3	63.1	16.3
CARTERVILLE HIGH SCHOOL	55.4	58.7	69.2	13.8
CALHOUN HIGH SCHOOL	39.9	42	51.7	11.8
DIVERNON HIGH SCHOOL	51.7	52.5	62.1	10.4

> About the Awards
> Academic Improvement
> 2004 Award Recipients
> News
> Research and Resources
> Contact Us
> P-20 Home Page

SOURCE: Northern Illinois University, n.d.

2. Teamwork [was] not a buzzword for these schools; It require[d] constant coaching, training, and the building of collaboration.

3. School teams studied test results and wrote action plans to improve both teaching and learning.

4. Improving test scores was only part of the challenge: The other part was changing attitudes toward change (Northern Illinois University, n.d.).

The trick is to not feel overwhelmed, but to begin. Whether you're an individual teacher or a team member, write a formative assessment and use the analyzed results to plan your next lesson. You will see how analyzed formative assessment results can inform and change your teaching, and you will become a believer in the process. Soon you will begin to trust data, focus on results, and engage in the practice of using data to drive your instructional practices. Before you know it, you too will be an ssessment-powered teacher.

Chapter Six Rubric: Harnessing the Power of Collective Wisdom

	Not Yet	Sometimes	Always
We use data to change curriculum and instruction.			
1. Our team uses data to recommend new texts and materials.			
2. Our team uses data to guide the pacing of instruction.			
3. Our team uses data to recommend systemic changes, such as graduation requirements.			
We use data to guide staff development.			
4. Our members learn new teaching strategies from one another. We "share the wealth."			
5. Our team uses data to recommend targeted training and staff development efforts.			
6. Our team understands how to use data and we have the ability to access student test data in a timely manner.			
We use data to guide student interventions.			
7. Our team uses test data to identify students' individual strengths and weaknesses and to make recommendations for interventions that will help students reach learning targets.			
8. Our team uses data to recommend new interventions in order to develop a sequential system for helping students take next steps to reach learning targets.			
9. Once students receive interventions, our team uses data to monitor student progress.			
We make the most of team time.			
10. Our team is organized by grade level and/or course.			
11. Our team has a regularly scheduled time to meet.			
12. Our team reflects on relevant, timely data regarding our students' progress toward learning targets.			
13. Our team meetings follow an agenda.			
14. Our team meetings result in identifying individual and programmatic changes and action plans that increase the learning of our students.			

Reflections

Ways this chapter has changed my thinking:

1.

2.

Next steps:

1.

2.

Glossary of Terms

Accommodations in testing are used to make allowances for a student's limitations in order to provide a level playing field in assessing a student's knowledge. Accommodations are based on the individual student's needs and are usually defined in documents such as an IEP. Common types of accommodations are extended time administrations for a timed test, large-print versions of a test, and having items or directions read aloud.

Accountability in education is the effort to validate that schools, teachers, local curriculum, instructional practices, and local assessments are preparing students to meet and exceed state standards and meet the challenges of the future. State tests are a driving force in the accountability movement and provide schools, students, parents, and community members with data on how well schools are doing at meeting state standards.

State testing is mandated by the federal accountability requirements of the No Child Left Behind Act; however, accountability at the local school level is determined by a school's ability to collect and use local test data to help students learn. Thus, responsibility for accountability rests not only with the state and the federal governments, but also with the local school's ability to develop an instructional program built upon common curriculum and assessments that produce reliable data so that teachers have the means to guide students' learning experiences.

Action Plans are the results of productive team meetings, where student assessment data are reviewed and steps to guide the instructional improvement process are discussed and defined. Action plans define what each teacher on the team will do next, identify any resources (including time and administrative support) that are needed, and specify when checks for progress will be done. Action

plans provide "next steps" for teachers once the team meeting has concluded.

Alignment in the development of curriculum, instruction, and assessment means that curriculum, instruction, and assessments "match" the standards. Curriculum defines the standards that will be taught as well as the sequence in which they will be taught. Instruction addresses content and teaches students the standards at the level and rigor required by the standards. Assessments measure students' understanding of the standards. When curriculum, instruction, and assessments are aligned, the same terminology and vocabulary used in the standards are used in the curriculum, instruction, and assessments.

Behaviorist thinking in education follows the belief (as pioneered by E. L. Thorndike) that rewards and punishments carry information (feedback) about the correctness of one's actions. Thorndike believed that practice does not make perfect unless it provides the opportunity for feedback and emphasizes the importance of feedback for learning. This thinking influenced modern ideas about formative assessment and the feedback it provides to enhance learning.

Benchmark Assessments are common exams administered several times a year to indicate student progress toward standards and provide benchmark data on this progress. Benchmark tests can be publisher- or teacher-made tests. When aligned with standards, benchmark test scores provide detailed information about student performance by standard and give teachers information to make instructional improvements based on data. Benchmark tests provide achievement data that are intermediate between classroom test data and state test data and thus are a predictive measure for state tests.

Criterion-Referenced Tests assess students' progress toward specific criteria or content standards that are the focus of instruction. Rather than ranking a student with a norm group, a CRT measures mastery of standards or learning targets for a student or group of students. Scores are usually reported in percentage of questions answered correctly. The goal of a CRT is to have students score at the upper end of the scale, indicating they have mastered the material that has been taught to them.

Demographic Imperative is a phrase used to make the case that teachers should alter the disparities in opportunities and outcomes

embedded in the American educational system. The marked dispari-
ties in educational opportunities, resources, and achievement among
students who differ from one another racially, culturally, and socio-
econonically are the basis for this argument.

Disaggregation of test data separates test results by subgroups and
allows teachers to see the progress specific groups are making toward
standards and learning targets. NCLB requires that state test data be
disaggregated by race, ethnicity, English proficiency, migrant status,
economic disadvantage, and disability. When schools disaggregate
test data from their own local formative and summative assessments,
they can monitor progress of students in subgroups and provide tar-
geted interventions for these subgroups.

Fairness in testing means that the test questions are not biased by
gender, race, ethnicity, or economic status and that the test questions
are focused on assessing the standards and not dependent on infor-
mation that may be biased.

Formative Assessments are assessments for learning, which indicate
what a student has learned up to a particular point in time, and are
used as a guide for further instruction to increase learning. Common
formative assessments assess what has been learned by using prod-
ucts and tests that are closely tied to a common curriculum. They are
usually teacher-created instruments used on a regular basis to mea-
sure student progress toward learning targets. Formative assessments
identify the strengths and weaknesses of students and provide valu-
able information needed to reteach a class, provide special help to
individual students, and/or change instructional pacing or materials
in the curriculum for future instruction.

Common formative assessments frequently are structured in the
form of a criterion-referenced test (CRT), which tests the criteria or
standards a student has been taught and measures how much knowl-
edge a student has gained from instruction. These tests are standard-
ized in that they are common exams administered at the same time
and under similar conditions to all students taking a particular course
or enrolled in the same grade level. They are criterion referenced
because they are based on the school's local curriculum, which is
linked to state standards. By developing formative assessments for
learning, teachers not only know which learning targets and stan-
dards students know and do not know, they also have the ability to
gather data to remediate students' weaknesses.

High-Stakes Testing refers to accountability tests that have serious consequences for schools, teachers, or students. The state tests required by NCLB are high-stakes tests.

Interrater Reliability determines that rubric-graded performances and projects, such as writing, artwork, speeches, and science projects, are rated consistently and fairly by different teachers (raters) over time. Interrater reliability is strengthened by training teachers or raters using models or anchors of performances that produce high, medium, and low scores based upon defined criteria contained in a rubric.

To achieve reliable scores, each performance is scored by two scorers (teachers or raters) based on previously defined criteria on a rubric. If the scorers are in agreement, the score is assigned. If the scores are discrepant or not in agreement, the scoring discrepancy is resolved by having a third scorer review the performance in question. When discrepancy is resolved, the rubric scores are recorded on a student roster for each class of students.

Item Analysis is a test-scoring procedure whereby test items are aligned to a learning target or standard using a "pin file." When the test is scored, items for each learning target or standard tested are combined into a percentage score for each learning target or standard. By reviewing an item analysis by learning target or standard report, one can determine how an individual student, a class, or a group of classes performed on a specific learning target or standard. These reports provide teachers, students, and administrators with valuable information regarding what students know and what students don't know.

Learning Targets are the key concepts and skills embedded in the standards. Because some standards are very broadly worded, a learning target may be part of a standard. Because some standards are very specific, a learning target may include concepts and skills included in more than one standard. Learning targets will guide curriculum, instruction, and the development of formative and summative assessments.

Norm-Referenced Tests assess students' knowledge of subject matter in relation to the knowledge of the norm group, which is a random sample of students chosen by the test developer to establish an average score. Students taking the test are then ranked according to how well they did in relation to the norm group by being given a score based on one or more of the following methods: 1) a grade-equivalent score, 2) a percentile score, which is the percentage of students a

student has scored as well as or better than other students, 3) assignment to a quartile, which is one of four categories into which percentiles are grouped, and/or 4) assignment to a stanine, which groups students into one of nine categories. Norm-referenced tests usually are composed of selected response items used to measure students' knowledge in specific content areas.

Performance Tests assess students' knowledge and skills by requiring students to construct a product, such as a written report or a project or complete a performance, such as a speech or a laboratory experiment. These tests do not have one correct answer but are judged upon known criteria, which usually are included in a rubric, which defines both the content and the quality of the performance.

A performance test may be a CRT in that the criteria are the basis for instruction and the grading criteria for the rubric. Though less likely, due to the complexity of scoring, a performance test may also be a rubric-graded normed test, where the student's score is compared to the scores of the norm group.

Pilot Tests are newly written tests that are administered to or "piloted" by a class or small group of students to check for poorly written items and the match between standards, curriculum, instruction, and test items. Once a small group of students has "piloted" the test, the pilot test is scored and weak items are eliminated or replaced. After the pilot, the test is then considered ready to be officially administered to a class or group of classes.

Reliability in testing means consistency in test results. If a test is reliable, students will provide similar responses to the test questions at different times or under different circumstances.

Rubrics are scoring tools that judge the quality of student work. They are an effective means for evaluating student performances, such as writing and speeches, or projects, such as science projects and artwork, because they define the content of a performance or project and the criteria by which it will be judged.

Scanners are devices that read text, illustrations, or marks on paper and translate the information into a format computers can use. Scanners digitize an image by dividing it into a grid of boxes and representing each box with either a zero or a one, depending on whether the box is filled in. The resulting matrix of bits, called a bit map, can

then be stored in a file, displayed on a screen, and manipulated by programs.

Optical scanners represent all images as bit maps. Therefore, information that has been scanned cannot be directly edited. To edit information read by an optical scanner, an optical character recognition (OCR) system is needed to translate the image into ASCII characters. Most optical scanners sold today come with OCR packages.

Most of the score reports used in this book rely on the scanning of test answer sheets filled in by students or rubrics filled in by teachers. After these sheets are scanned, the data are organized in a computer into reports requested by teachers, data coaches, or administrators. The reports are then printed and used by teachers and teacher teams.

Selected Response/Forced Choice/Objective Tests frequently are used to assess students' knowledge of factual information. Multiple choice, true-false, and matching are common formats for these tests, and they require students to select a response from a list of choices or supply a brief answer. If test items are aligned with standards or learning targets, item analysis by standard or learning target can be used to provide valuable information regarding student progress toward standards and learning targets.

Standardized Tests are constructed and administered so that students are assessed under uniform conditions so that students' test performance may be compared and not influenced by differing conditions. Both formative and summative tests may be standardized, and both norm-referenced and criterion-referenced tests may be standardized. Depending upon test content, a standardized test may or may not test standards or learning targets, which define knowledge and skills to be learned as a result of instruction.

Summative Assessments are assessments of learning, which sum up what a student has learned at a particular point in time. An end-of-course or grade test, which is used for the purposes of determining that a student has mastered the skills and learning necessary to proceed to the next level as well as for the purposes of assigning a final grade, is a summative assessment.

Standardized achievement tests also are summative assessments. Schools frequently use the Iowa Test of Basic Skills or the California Achievement Test to measure students' achievement in selected subjects, such as reading, math, and science. State-developed tests based on the state standards also are summative assessments. State tests

and other summative assessments give state officials and school administrators a picture of what a student or groups of students have learned, report whether or not students have "exceeded," "met," or are "below" state standards, and are useful for comparisons of students or groups of students.

Summative assessments frequently are normed, standardized tests that are reported in total scores for subject areas, such as math, science, reading, and so on. The scores frequently are used to classify individuals or groups of students.

Validity in testing means that the test questions actually measure what they are intended to measure. In terms of assessment-powered teaching, the test questions are valid when they measure and give us feedback on our students' progress to our learning targets, because the test questions are aligned with the learning targets.

References

Ainsworth, L. (2007). Common formative assessments: The centerpiece of an integrated standards-based assessment system. In D. Reeves (Ed.), *Ahead of the curve* (pp. 79–101). Bloomington, IN: Solution Tree.

Almeida, L. (2007). The journey toward effective assessment for English language learners. In D. Reeves (Ed.), *Ahead of the curve* (pp. 147–164). Bloomington, IN: Solution Tree.

Arter, J., & McTighe, (2001). *Scoring rubrics in the classroom.* Thousand Oaks, CA: Corwin.

Bangert-Drowns, R. L., Kulik, C., Kulik, J., & Morgan, M. (1991). The instructional effect of feedback on test-like events. *Review of Educational Research, 61*(2), 213–238.

Banks, J., Cocharna-Smith, M., Moll, L., Richert, A., Zeichner, K., LePage, P., et al. (2005). Teaching diverse learners. In L. Darling-Hammond & J. Bransford (Eds.), *Preparing teachers for a changing world* (pp. 232–274). San Francisco: Jossey-Bass.

Beck, J. (2008, Fall). Education and reform that won't be left behind. *Inquiry,* 6–8.

Beck, J. (2009, Spring). Making the connection between culture and mathematics. *Inquiry.* Retrieved October 20, 2010, from http://www.sesp.north west ern.edu/news-center/inquiry/archives/2009-spring/making-the-connec tion.html

Bellon, J., Bellon, E., & Blank, M. A. (1992). *Teaching from a research knowledge base.* New York: Merrill.

Bransford, J., Derry, S., Berliner, D., Hammerness, K., & Beckett, K. (2005). Theories of learning and their roles in teaching. In L. Darling-Hammond & J. Bransford (Eds.), *Preparing teachers for a changing world* (pp. 40–87). San Francisco: Jossey-Bass.

Colorado Department of Education. (2010). *Colorado content standards: Social studies grade level expectation: Third grade.* Denver: Colorado Department of Education.

Commercial Club of Chicago. (2003). *Left behind.* Chicago: Education Committee.

Davies, A. (2007). Involving students in the classroom assessment process. In D. Reeves (Ed.), *Ahead of the curve* (pp. 31–58). Bloomington, IN: Solution Tree.

Dell'Angela, T. (2004, August 5). City schools get gold star. *Chicago Tribune,* pp. 1, 16.

Delpet, L. D. (1995). *Other people's children: Cultural conflict in the classroom.* New York: New Press.

deVise, D. (2009, February 28). ESOL students in Maryland and Virginia leaping ahead of U.S. peers. *Washington Post.* Retrieved March 23, 2009, from http://pqasb.pqarchiver.com/washingtonpost/access/1652951041 .html?FMT=ABS&FMTS=ABS:FT&date=Feb+28%2C+2009&author=Dan iel+de+Vise+-+Washington+Post+Staff+Writer&desc=ESOL+Students+ in+Md.%2C+Va.+Leaping+Ahead+of+U.S.+Peers.

DuFour, R., DuFour, R., Eaker, R., & Many, T. (2010). Learning by doing: A handbook for professional learning communities at work (2nd ed.). Bloomington, IN: Solution Tree.

Elawar, M., & Corno, L. (1985). A factorial experiment in teachers' written feedback on student homework: Changing teacher behavior a little rather than a lot. *Journal of Educational Psychology, 77*(2), 162–173.

Etheridge, C. P., & Green, R. (1998). *Union district collaboration and other process related to school district restructuring for establishing standards and accountability measures.* (A technical report for the Twenty-First Century Project). Washington, DC: National Education Association.

Fuchs. L., & Fuchs, D. (1986). Effects of systematic formative evaluation: A meta-analysis. *Exceptional Children, 53*(3), 199–208.

Fullan, M. (2001). *Leading in a culture of change.* San Francisco: Jossey-Bass.

Gay, G. (1993). Building cultural bridges: A bold proposal for teacher education. *Education and Urban Society, 25*(3), 285–299.

Guskey, T. (2007). Using assessments to improve teaching and learning. In D. Reeves (Ed.), *Ahead of the curve* (pp. 15–29). Bloomington, IN: Solution Tree.

Hattie, J. A. (1992). Measuring the effects of schooling. *Australian Journal of Education, 36*(1), 5–13.

Hattie, J. A., & Timperley, H. (2007). The power of feedback. *Review of Educational Research, 77*(1), 81–122.

Hodgkinson, H. (2001). Educational demographics: What teachers should know. *Educational Leadership, 58*(4), 6–11.

Illinois State Board of Education. (1997). *Illinois learning standards, goals 11 and 17.* Springfield: Illinois State Board of Education.

Marzano, R. J., Kendall, J. S., & Gaddy, B. B. (1999). *Essential knowledge: The debate over what American students should know.* Aurora, CO: Mid-Continent Regional Education Laboratory.

McTighe J., & O'Conner, K. (2005). Seven practices for effective learning. *Educational Leadership, 63*(3).

National Center for Education Statistics. (2002). *Context of elementary and secondary education (Indicator 28): Inclusion of students with disabilities in regular classrooms.* Washington, DC: U.S. Department of Education.

National Center for Education Statistics. (2007a). *Status and trends in the education of racial and ethnic minorities.* Retrieved April, 20, 2010, from http://nces.ed.gov/pubs2007/minoritytrends/tables/table_7_1.asp.

National Center for Education Statistics. (2007b). *Status and trends in the education of racial and ethnic minorities.* Retrieved April 20, 2009, from http://www .nces.ed.gov/pubs2007/minoritytrends/tables/table_9b.asp.

National Research Council. (2001). *Knowing what students know: The science and design of educational assessment.* Washington, DC: National Academies Press.

Northern Illinois University. (n.d.). *Academic improvement.* Retrieved September 21, 2010, from http://www.p20.niu.edu/P20/acadimprovea wards/acad_improv.shtml

Pena, X. (2009, March 26). Volunteers helping to boost school's scores. *The Desert Sun,* p. 1.

Reeves, D. (2008, December). The learning leader/Looking deeper in the data. *Educational Leadership 66*(4), 89–90.

Rosenholtz, S. (1991). *Teacher's workplace: The social organization of schools.* New York: Teachers College Press.

Ryan Holy Eagle (n.d.). *Improving results with Interwrite, St. Francis Indian School, South Dakota, A case study.* Retrieved August 18, 2010, from http://www.einstruction.com/company/case_studies/IWL%20St.%20 Francis.pdf.

Scott Foresman. (1988). *Advanced dictionary.* Northbrook, IL: Scott Foresman.

Shepard, L., Hammerness, K., Darling-Hammond, L., Rust, F., Snowden, J., Gordon, E., et al. (2005). Assessment. In L. Darling-Hammond & J. Bransford (Eds.), *Preparing teachers for a changing world* (pp. 275–326). San Francisco: Jossey-Bass.

Shaw, J. (2005). Getting things right at the classroom level. In J. Herman & E. Haertel (Eds.), *Uses and misuses of data for educational accountability and improvement* (pp. 340–357). Malden, MA: Blackwell Publishing.

Sindelar, N. (2006). *Using test data for student achievement: Answers to No Child Left Behind.* Lanham, MD: Rowman and Littlefield.

Stiggins, R. J. (2002, June). Assessment crisis: The absence of assessment for learning. *Phi Delta Kappan, 83*(10), 758–765.

Stein, L. (2009, Spring). Diversity as a resource for learning. *Inquiry,* 6–10.

Surowiecki, J. (2004). *The wisdom of crowds.* New York: Doubleday.

U.S. Census Bureau. (2009). *People QuickFacts.* Retrieved April 19, 2009, from http://quickfacts.census.gov/qfd/states/00000.html.

Wiggins, G. (1998). *Educative assessment.* San Francisco: Jossey-Bass.

Wong, S. (2009, February 28). ESOL students in Maryland and Virginia leaping ahead of U.S. peers. *Washington Post,* p. A1.

Index

Academic freedom, 12
Accommodation, 86, 122
Accountability, 3, 122
 advanced placement program, 10
 demand for, 20–21
Achievement. *See* Student achievement
Action plans, 20, 115, 122–123
Advanced placement programs, 10
African American student
 achievement, 88, 89
African-centered schools, 86
Alignment, defined, 123. *See also*
 Standards-based curriculum and
 assessment alignment
Alphabetical student report with grade,
 48, 48–49
Assessment, 3
 accommodations, 86, 122
 assessments for learning, 11
 formats, 19–20
 of learning, 127
 teacher and school accountability, 3
 See also Benchmark assessments;
 Forced-choice tests; Formative
 assessments; Rubric-graded
 assessments; Summative
 assessments
Assessment analysis tools. *See*
 Assessment tools and software
Assessment center, 109–110
Assessment data analysis:
 alphabetical reporting with grade, 49
 analysis of forced-choice assessments,
 6, 43, 46–47, 52, 55, 90, 91–92
 analysis of rubric-graded
 assessments, 62, 98–100

class item analysis, 6, 43, 46–47,
 52, 54
course item analysis, 50, 62, 90,
 91–92, 98–100
curriculum teaching pace and, 4–5
enhancing teacher effectiveness, 8–9
forced-choice and rubric-graded
 assessments, 70, 109
individualized item analysis, 70–71
informing teaching using, 38–44,
 55–61
school system and, 13, 109–110
teacher-created classroom tests, 7
teams and, 13, 114
understanding reports, 109
See also Item analysis
Assessment data analysis, automated.
 See Assessment tools and software
Assessment data analysis, feedback
 applications. *See* Corrective
 feedback
Assessment data disaggregation, 1, 8,
 21, 87–93
Assessment literacy, 21, 70
Assessment reports, 5, 8, 20, 42–44,
 51, 109
 alphabetical reporting with grade,
 48–49
 by class, 45–48, 52, 54
 by learning target, 6, 46–47, 50, 62,
 90, 91–92, 98–100
 disaggregated data, 87–90, 95, 98–100
 forced-choice 6, 46–47, 50, 52–54, 90,
 91–92
 individualized, 53, 70, 73–74
 rubrics and, 53, 58, 61